FADING ADS OF

DETROIT

ROBERT C. ALLEN

THE
History
PRESS

Published by The History Press
Charleston, SC
www.historypress.com

All photographs by Robert C. Allen.

First published 2018

Manufactured in the United States

ISBN 9781467138772

Library of Congress Control Number: 2018936072

Notice: The information in this book is true and complete to the best of our knowledge. It is offered without guarantee on the part of the author or The History Press. The author and The History Press disclaim all liability in connection with the use of this book.

For Rachel.

CONTENTS

ACKNOWLEDGEMENTS

MANY THANKS to John Carlisle, Trevor Hughes, John Gallagher, Adrienne and Chris Shonk, Maryann Struman, my parents, all the writers who filled precious archives, the makers, the doers, the painters and the freaks. And, of course, my dear wife, Rachel Allen, who kindly endured our first year of marriage as I ran all over the city hunting signs and stories.

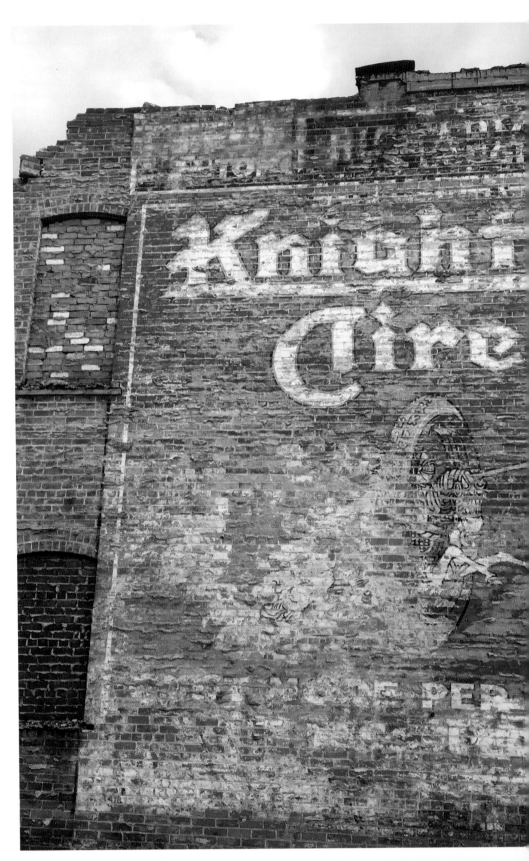

INTRODUCTION

HISTORY CAN APPEAR in strange places. It coats bricks lining abandoned factories and homes. With help from an excavator, it emerges from shrouds of concrete and charred wood. It also stands in the open, largely unnoticed and blurred under sunlight, partly shaded by decades of growing weeds along a city street. Its hand-painted, time-traveling messages might encourage you to buy hardware, eat ice cream or use car tires that no longer exist. And if you ask around, the meanings behind a city's fading signs and advertisements inevitably reveal themselves as threads to an American narrative of hard-earned successes, weird surprises, horrible tragedies and sweet love stories.

LEFT A ghost sign advertising Knight Tires became visible on Grand River Avenue and Avery Street after an adjacent building was demolished in about 2015.

On Detroit's west side, there's a bar that opened in the 1940s and was owned by a professional boxer, a World War II veteran who received a Purple Heart after the Battle of the Bulge. The bar closed in the 1980s and decayed for about fifteen years. At the turn of the twenty-first century, a musician's son converted it into a social club to honor his dying father. For the quiet, run-down neighborhood with boarded-up buildings and burned-out streetlamps, it became a literal beacon of light. Today, it's a lounge where people young and old gather for drinks, eats and live music, dancing on the original, sprung wood floor. Outside, the building's brick wall signs are like bookends, advertising the old business (and, barely, Pepsi) on one side and the new lounge on the other. On the city's east side, there's the shop where a first-generation American tailored tuxedos and customized shirts for bowling teams. It eventually became a party store (a colloquialism for bodega or corner store), later a caved-in mess of bricks and, soon, urban farmland employing former prisoners.

Detroit's aspiring comeback is well documented, from local to international media coverage. The accelerated changes in cityscape mean near-constant demolitions to the city's roughly eighty thousand vacant structures. Hand-crafted signs—mostly from the early to mid-twentieth century—are increasingly being uncovered and also torn down. Of the signs you'll find in this book, most represent businesses that no longer exist; many continue to operate in some form, often against tough odds. Every photo was taken in 2017, and several of the featured ghost signs have already disappeared. In one case, I arrived outside an old bar in the Delray neighborhood just in time to see a backhoe claw down its brick wall sign.

These photos capture the Detroit cityscape during a pivotal moment. This was the year all the professional sports teams returned to play inside city limits. Ground was broken downtown on the city's yet-unnamed tallest skyscraper, at about eight hundred feet, to exceed the Renaissance Center (completed in 1977) in height by more than seventy feet. In the summer, we marked fifty years since the riots (also known as rebellion, civil disturbance or uprising). And just three years after the city exited its historic bankruptcy, Detroit's downtown and Midtown core in 2017 was flush with investment, hip new restaurants, craft breweries, renovated apartment buildings and a new rail system. A massive demolition program continued razing buildings across the city, reshaping neighborhoods that in some areas looked increasingly like prairies. Crime was still a major problem: In September 2017, the Federal Bureau of Investigation (FBI) released a report showing Detroit to be the most violent big city in America the previous year, with 303 murders—quadruple the number for Los Angeles, which has nearly six times more people—among 13,705 violent crimes. Detroit's

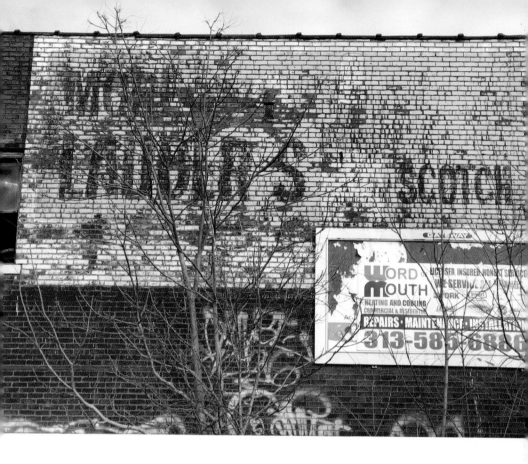

police chief disputed the FBI, saying that an old computer system skewed the numbers and arguing that violent crime was down 5 percent in 2016 and had been trending downward since 2013, as Tresa Baldas reported in the *Detroit Free Press*.

The *Free Press* is among many newspapers, interviews, books and websites used to research stories behind the signs featured in this book. In some chapters, the photos are sorted by geography. But mostly, their placement is driven by the stories of people from a diversity of cultures and countries who call Detroit home.

To get an idea of just how fleeting, yet plentiful, hand-painted signs are in Detroit, consider the book *Talking Shops: Detroit Commercial Folk Art* by David Clements,

ABOVE A Lauder's Scotch advertisement is visible on a vacant building on Forest Avenue near Flower Court.

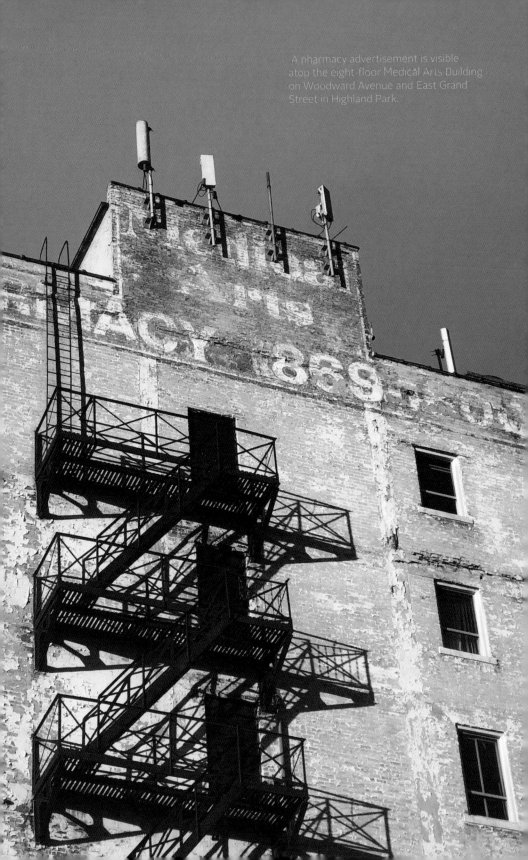

A pharmacy advertisement is visible atop the eight-floor Medical Arts Building on Woodward Avenue and East Grand Street in Highland Park.

published in 2005. It's loaded with more than 150 pages of gorgeous photography featuring hand-painted Detroit business signs. It was released only about thirteen years before this book, but not one sign from it can be found in these pages. That wasn't on purpose. Many if not most of the signs Clements shot have already disappeared. If you were driving southbound on Hamilton Avenue in 2012, near Moss Street in Highland Park, you would probably have noticed two colorful, vintage advertisements on a wide, two-story brick wall—one bright blue and red and the other black and gold. The first pitched "Honor Bright Boys Blouses, Shirts and Playsuits, for Real Boys from Morn Till Night" and featured two boys with their ties flapping above their shoulders. The other, "Black Beauty Triple Stitched Twill Sateen, a Thoro Bred Work Shirt," displayed the bust of a horse across from a man in a black shirt. If you were there in 2009, the wall would have been invisible—for decades, it was connected to the next-door building, protecting the signs' paint from sunlight and weather. If you took that same drive in 2017, you'd see a bland, beige-colored coat of paint over the entire wall. The advertisements are gone, and you won't find them in this book. They're but one example of just how delicate and ephemeral these signs are.

Across the city, from sparsely populated neighborhoods to downtown skyscrapers, massive amounts of history are within reach—just obscured, like dirt over fossils. Some walls are like Fordite, the jewelry made from stone-like layers of different-colored paint left over from an old process Ford used to paint cars. The paint on walls can hide stories within its layers. And there are several examples in this book where a fresh coat of paint, used to cover an old sign with a new one, has started wearing off. The image behind it—perhaps left in lead paint, which soaks more deeply into brick than newer (and safer) formulas—has started bleeding through.

It should also be pointed out that Detroit is an especially great place for signs. William Stage, who's traveled the United States shooting photos of signs, wrote that "while wall signs are found throughout the land, nowhere are they more prolific and, by virtue of sheer extant volume, better preserved than in the Midwest," according to his book, Ghost Signs: Brick Wall Signs in America. "Why the profusion? Well, the Midwest is studded with clay quarries needed for the production of smooth, red brick—the best kind on which to paint. This book's final chapter focuses on the painters and signs of some national trends that remain visible in Detroit.

Uniquely Detroit-born brands such as Faygo and Carhartt left marks on numerous Detroit walls over the past one hundred or more years. As the city's roughly 140 square miles were traversed to collect this book's photos, some of these brands' vintage markings appeared in odd places across the city. The

chapter "The Names You Know" tells their stories.

Signs of Detroit's rejuvenation popped up unexpectedly in many places. The stories often show the interconnectedness of people and culture through these signs, as well as how they fit in with the city's historic rises, falls and eccentricities. Some of the stories found me rather than the other way around, occasionally catching me off guard as I scurried through the streets taking the thousands of photos that were whittled down by beauty, historic value or uniqueness. All the photos were shot with an iPhone, usually from the street or sidewalk. There was no trespassing or special permission involved, and the photo locations are included in the captions. I hope the result offers a little inspiration to go see these authentic, often folksy pieces of art in person. Before it's too late.

RIGHT A ghost advertisement for Laurel Stoves and Ranges is seen along Gratiot Avenue south of Joseph Campau Street.

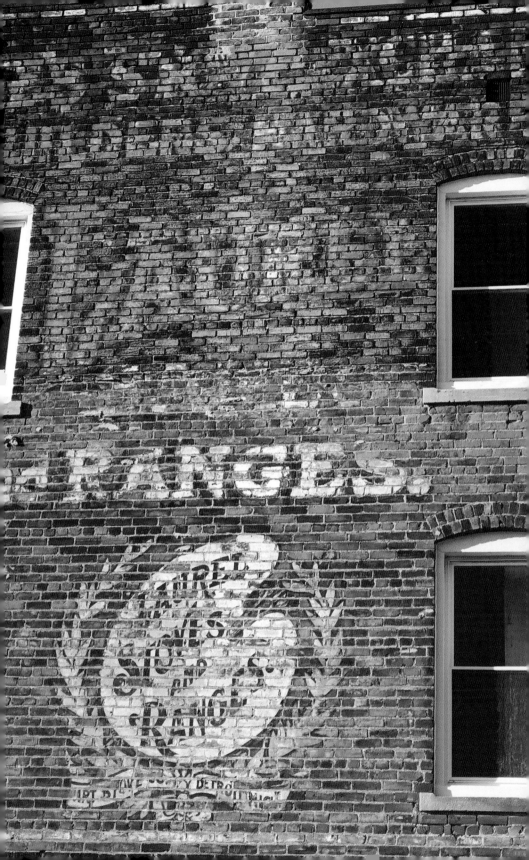

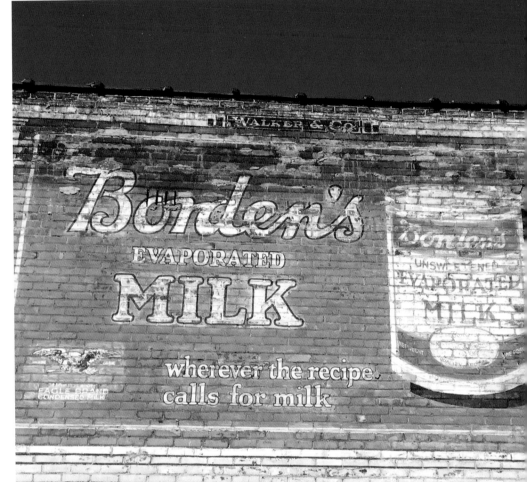

NEWCOMERS

A NAZI PRISON CAMP SURVIVOR in a brown, secondhand suit sold a pint of his blood for five dollars on Woodward Avenue and then collapsed on a nearby sidewalk. Kazimierz Nowotny was a thirty-six-year-old Polish immigrant with a pregnant wife, seven kids and no job. The family had moved to Detroit three months earlier, hoping for opportunity. But the small man with wiry brown hair wasn't very good at speaking English. He lacked a trade, and the welfare office said he hadn't been a resident long enough to qualify for government aid. To feed his family, he visited a blood center on Woodward for some grocery money. After the exhausted Nowotny fell to the sidewalk, police officers picked him up and took him to a hospital. He received fruit juice and a little rest before resuming his job hunt. He tried an employment office on Conant Street. No luck.

The father, a World War II veteran, became increasingly desperate: groceries and a bus fare had turned the five dollars blood-bank money to eighty-one cents. Nowotny dreaded staying in the house on Detroit's east side, where the children cried for milk. The next day, he went to a bar and ordered two

whiskeys. The bartender suggested he try the newspaper. So he did. "I have no hope. Maybe I take a gun," Nowotny sobbed, speaking to a *Detroit Free Press* reporter, "and shoot whole family."

That quote was so jarring that the newspaper ran it twice—on April 12, 1957, detailing the predicament of the destitute father "down to 11 cents and tears," and on the next day's front page, after the Nowotny family's fortunes had flipped. "Detroit opened its heart to the Kazimierz Nowotny family Saturday and overwhelmed it with help," reporter Ed Winge wrote in the April 14, 1957 edition. It included a photo of the mother and children sitting around a table covered in food: bread loaves, Corn Flakes, Minute Rice, milk and even some tissues.

Police officers, a "chic, platinum blond in a fur jacket who drove up in a 1957 limousine," an unemployed factory worker and a Chrysler employee were among the diverse crowd of people to visit the family, insisting the Nowotnys take their donations of food, clothing and money, Winge wrote.

One man arrived at the house with seven baby chicks for the children to play with as he took Nowotny to see about a job. Of the more than two dozen jobs offered, Nowotny ended up working for the Mac-O-Lac Paint factory on 5400 East Nevada Avenue. "After that, he got a lot of job opportunities—lots of nice offers by a lot of kind, wonderful, beautiful people," said Fred Nowotny, one of Kazimierz's sons, who was age sixty in 2017.

Like many thousands of people, the family came to America to start a new life and then moved to Detroit after hearing about good jobs. "We were kind of like the Beverly Hillbillies," Fred Nowotny said. "My dad piles us up in this truck and all of our belongings."

Fred's memories are inherited. When his family was moving cross-country, as when his blood-depleted father collapsed on the street, he was in his mother's womb. The family's first Detroit address, where rent was overdue at 2220 Bewick Street, today is one of several grassy lots, across the street from other grassy lots, on an east-side block that's more prairie than neighborhood. But back then, it was a neighborhood where this immigrant family and others found a foothold.

Born in Poland, Kazimierz Nowotny was a teenager when he was captured by the Nazis in 1939 as Germany's Blitzkrieg swept through the country. "He had just enlisted, and they captured his battalion. Poles on horseback didn't really stand a chance," Fred Nowotny said. For the rest of World War II, his father was a prisoner. "The experience he had in the labor camp, I think, really affected him. It made him mean. [There was a] short temper with him, and it kind of came out often in his life," he said.

After the war, Kazimierz met and married his wife, Marie, a German—which was unusual, as their home countries "really hated each other," Fred Nowotny said.

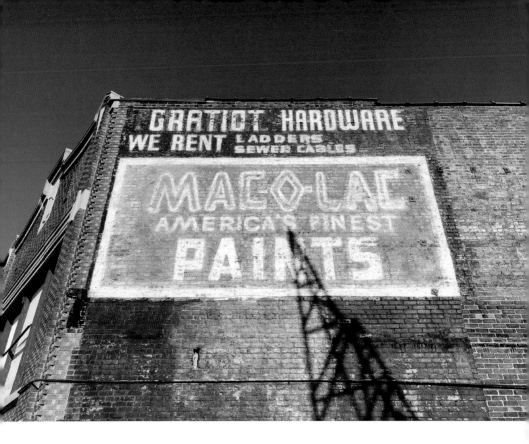

ABOVE Mac-O-Lac Paints is advertised on the side of Gratiot True Value Hardware (Gratiot Avenue and East Forest Avenue), which went out of business in 2017.

They had their first three kids in Germany before moving to the United States in April 1951 for better opportunities. They started in Arkansas, where they lived in a shack on a cotton farm. A cousin who worked as an engineer for one of the "big three" automotive companies recommended they move northeast to Detroit, where wages were higher. But for Kazimierz, finding work wasn't as easy as it sounded. The *Free Press* story changed everything.

With help from the cash donations, the family moved to a four-acre farm north of Richmond, where they raised chickens, a pig, ducks, geese and pigeons. When the *Free Press* caught up with Kazimierz again in December 1957, he was commuting all the way into Detroit for work. The Mac-O-Lac job had lasted a few months before an

illness caused him to be out for more than two months. Then he worked at General Magnetic Corporation. Fred Nowotny, who was born that August, said his father had a bit of a problem: "He didn't take orders well."

The Nowotny parents went on to have a total of ten children and ended up moving the family to Carsonville, on the eastern side of Michigan's Thumb, in about 1963. Fred Nowotny said that through the 1960s and the 1970s, his father peddled poultry and butchered hogs, selling them at Eastern Market. "We didn't have running water until I was in sixth grade," he said. "We took a bath once a month, whether we needed it or not....We got through it all. I have no complaints."

Fred Nowotny and several of his siblings went on to graduate from college and find success. He graduated from Central Michigan University in 1980 and became a teacher. But his father expected him to continue the family business. "He was ready for me to take over, going to Eastern Market," Fred Nowotny said. "He got real mad at me and told me to get the hell out of the house, in his Polish accent. Once he knew that none of us had any interest in what he did, he retired."

Kazimierz Nowotny, who had paid for his house but didn't otherwise have much savings, spent the rest of his life on the small Michigan farm. "It was sad, because he really didn't do a lot. Sometimes, he would go to a bar and converse with people," Fred Nowotny said. His mother died in 1988, and his father died in 2007.

In the 1980s, he moved to Texas, where jobs were more promising. He got married and taught history, geography and government for about eight years before moving back to Michigan. His wife, also a teacher, was from Livonia, so they moved there after she was offered a good job. But Nowotny had a tough time finding work as a history teacher. He tried sales and didn't like it. After several months, he resorted in March 1990 to a district where there were always openings. "I said, 'Screw it, I'm just going to go and apply to Detroit,' because nobody else really was," he said.

He returned to the city where compassionate souls, more than thirty years earlier, had helped his desperate parents feed their children, getting the family on its feet. But by 1990, poverty had become a major problem in Detroit. Since Fred Nowotny's childhood, the city's population had declined by 38 percent, from about 1.7 million to 1 million, according to U.S. Census data. Manufacturing jobs, which had previously helped fuel a robust economy, declined as well. For the next twenty years, Fred Nowotny taught children here. He started at Pulaski Elementary School, between 8 Mile and 7 Mile

Roads on the city's east side. He taught history, reading and civics and coached basketball. "The first day I was there, at the end of the day, I got home. I told my wife, 'I'm not going back,'" he said.

It was March 1990, and he was the fourth teacher those students had had that year. The other teachers, he said, were taking bets in the lounge on how long he'd last. "Kids were throwing books at each other. No discipline. I fought it. I did everything my experience taught me. Eventually, it came around," he said. "After battling through it, I enjoyed the job. I became very good at it. I hear people bad-mouth Detroit teachers, but they don't know what these teachers do—how much money they spend out of their own pockets."

Fred Nowotny, while in Texas, had taught children from a range of backgrounds—some very affluent, on track toward elite universities such as Harvard and Yale. In Detroit, he said he initially was frustrated with students who had problems showing up for class in the first hour. "Then I changed my attitude about it. The struggle those kids go through, just to get to school.... People in that city have been basically forgotten. It's a crime—in a country that has as much wealth as we have—what goes on in the schools," he said.

In 2017, Pulaski Elementary-Middle School was in danger of closing. It was one of twenty-three in the Detroit Public Schools Community District that performed in Michigan's bottom 5 percent in 2015 and 2016, according to a report in the *Detroit News*.

Fred Nowotny's years with the district, which included two other schools, influenced his perspective on Detroit's much-hyped improvements to areas near the city's core—which appears increasingly prosperous while outer neighborhoods endure high crime rates and poverty. "It's nice that they've put on a nice façade downtown," he said. "As long as [visitors] can get down there and not see all the blight around it."

He now lives in Grass Lake Charter Township, outside Jackson, west of Ann Arbor. He and his wife have two daughters, both of whom went on to become teachers. Reflecting on his experiences, Fred Nowotny continues to believe in the city: "I think the people of Detroit are some of the most generous people that you're going to find anywhere."

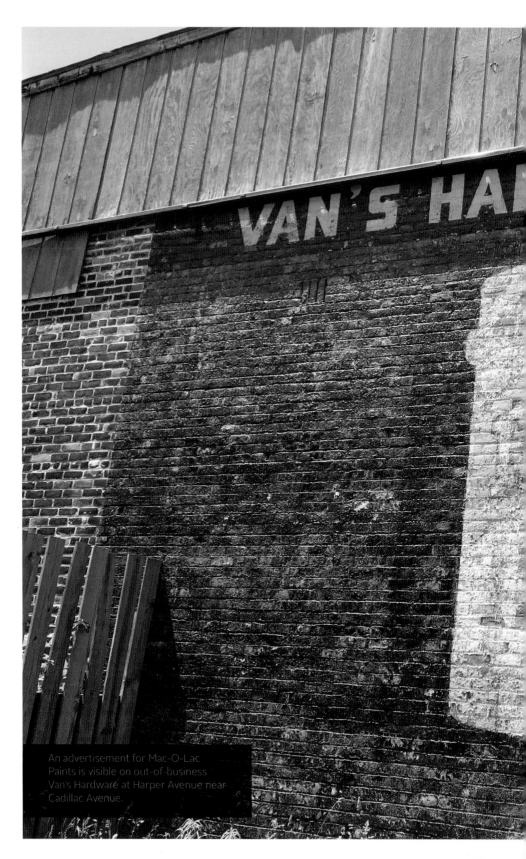

An advertisement for Mac-O-Lac Paints is visible on out-of-business Van's Hardware at Harper Avenue near Cadillac Avenue.

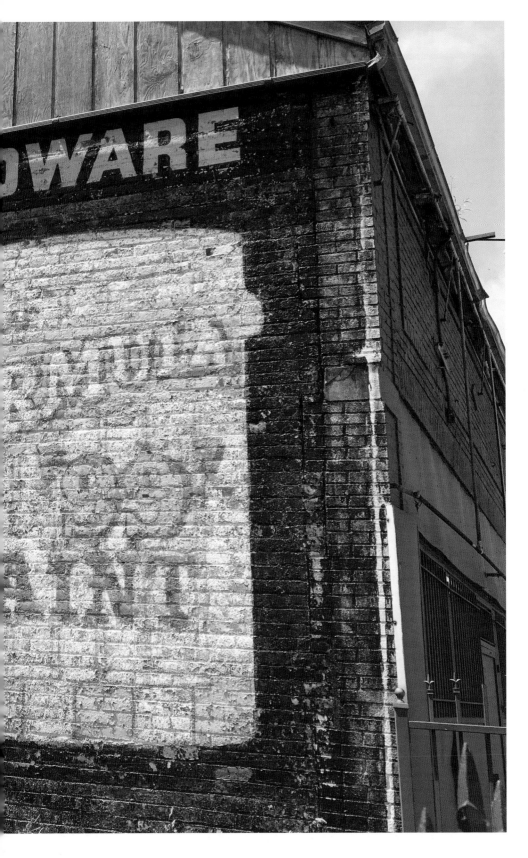

MAC-O-LAC

The paint company that gave Kazimierz Nowotny a chance in 1957 was owned by a Jewish immigrant from Poland who built an exceptionally good life in Detroit. Walter L. Field was eighteen when he moved to the city in 1920. He initially worked in construction. When the Great Depression hit, work became tougher to find. "But people still were trying to preserve what they had, and with a chemist he went into the varnish business," according to a July 1963 *Detroit Free Press* article. Field and the chemist acquired the Michael McNamara Varnish Works in 1931 and changed the name to Mac-O-Lac. By the early 1960s, the paint was being sold at three hundred locations across Detroit.

Field had a passion for poems, and he became known as "Detroit's businessman-bard." He wrote a poetry book called *A People's Epic*, tracing four thousand years of Jewish history, which he wrote during about five years of traveling the world on business trips. "The more successful you are, the more you are obligated to the community, the country—to the world, for that matter....And you must hold onto your individuality, try to express something, add your bit of philosophy to the life-stream of mankind," he told the *Free Press*.

Field was known as an author, entrepreneur and community activist. He was one of the founders of *Detroit Jewish News*, which has been published since 1942. Field expanded Mac-O-Lac with New Mexico Paints in 1950, and he sold the companies and retired in 1974, according to his obituary in the December 26, 1999 edition of the *Detroit Free Press*. Field died at age ninety-eight in Bloomfield Hills.

Signs advertising the paint company appear on old brick walls across Detroit, especially hardware stores. Bright yellow letters remain clearly visible on a black background over the east-facing wall of 9946 Harper Avenue, an apparently vacant building near Gratiot Avenue on Detroit's east side. The former Van's Hardware is long closed, but the image remains of a white and yellow paint can advertising Formula "99."

Mac-O-Lac Formula "99" was a popular latex paint used on home exteriors. The trademark, in use since 1954, expired in 2004, according to data from the State of Michigan.

POMERANTZ HARDWARE

About two miles south of the Van's Hardware sign is a building that operated as a hardware store for most of the past seventy years until it went out of business in 2017. On the south-facing wall of 6844 Gratiot Avenue, near East Forest Avenue, the white and red letters over a blue background read "Mac-O-Lac; America's Finest Paints." Below it, there's a black square that's apparently been painted over. It previously had shown the same yellow, white and blue image of the paint can seen on Van's Hardware.

Above the Gratiot hardware store's Mac-O-Lac sign, there are the words "Gratiot Hardware." From 1948 to 1979, the World War I–era, two-story building was Pomerantz Hardware, owned by two brothers who were the sons of immigrant Jews from Russia, according to Steven Pomerantz, the son of one of the owners, in a *Belt Magazine* article published in 2013. "It was what we now term an 'old-fashioned hardware store,' complete with bins of nails, wire rug beaters, washboards, nuts and bolts that could be purchased by the piece, and wallpaper steamers to rent," Pomerantz wrote. "There was even a giant 'Mac-O-Lac' brand paint can affixed to the roof of the building so that drivers coming into the city knew what kind of business went on inside, much like businesses that had barber poles and giant eyeglasses in earlier times."

The store made it through the 1967 riots unscathed, which Pomerantz attributes to his family's compassion for the neighborhood. As crime escalated in the ensuing years, the store's windows were boarded up or converted to plate glass and then thick plastic glass that was less susceptible to BB gun rounds that riddled the windows. Later, a metal grate system was installed across the storefront, and steel-plated doors were added to the rear entrances, each secured with three heavy padlocks. Despite all the fortifications, a few thieves hid under some stairs when the store closed one night, used a sledgehammer and pickaxe that were on display and broke into the store's safe and cash register before unlocking the rear doors and escaping. But Pomerantz wrote that the business continued to operate until 1978, when it was sold after Pomerantz's father discovered that his brother had been embezzling money for years.

By the fall of 2017, what had most recently been a TrueValue Hardware had posted new, big yellow signs: advertisements that it was closing with a liquidation sale.

DETROIT, FOR OPPORTUNITY

Immigrants from across the planet are essential to Detroit's identity, and many of the brands featured in this book are connected directly to them. Data from the 1960 U.S. Census—shortly after Kazimierz Nowotny arrived with his Polish and German family—show that 12.1 percent of the city's 1.7 million population was foreign-born.

Detroit's foreign-born population declined, along with the city's overall population, into the 1990s. But since then, the rate of foreign-born Detroiters has increased with each census, from 3.4 percent in 1990 to an estimated 5.5 percent in 2016 (when the city's population was down to about 673,000). The source countries also changed, as discriminatory limits were gradually lifted through the twentieth century.

"The makeup of Detroit—European (Poles, Germans, Ukrainians, etc.) was heavily influenced by the national quota system that either forbid certain groups (Asians, for instance) or maintained extremely small quotas," said Kurt Metzger, the retired founder of Data Driven Detroit, in a 2014 article by Bill Shea in *Crain's Detroit Business*. As the quota system was loosened, the immigration shifted to include more people from across the Middle East, Asia and Latin America.

In Detroit, you can celebrate St. Patrick's Day in Corktown, Cinco de Mayo in Mexicantown and Detroit Greek Independence Day Parade in Greektown. Paczki Day, in the Detroit enclave of Hamtramck, is a Polish celebration with jelly doughnuts ahead of the Catholic observance of Lent.

LEFT Xochimilco Restaurant's sign is visible on the corner of Bagley Street and Twenty-Third Street.

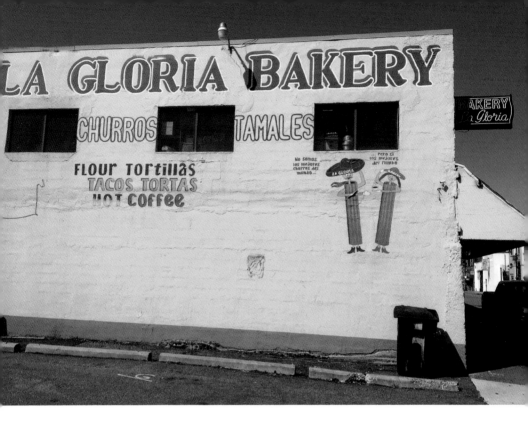

ABOVE La Gloria Bakery's sign is visible on the building's east-facing side on Bagley Street near the West Fisher Freeway service drive.

In 2016, more than half of Detroit's foreign-born residents were from Latin America, according to U.S. Census data. Mexicantown in southwest Detroit begins, coincidentally, less than a mile from Canada, a few blocks from the Detroit River. The area was founded in the 1920s, as families arrived and moved into a southwest area of the city, according to the *Detroit Almanac*. If you take Vernor Highway west from Michigan Avenue, you'll pass by worn buildings housing the city's best Mexican restaurants, bakeries and apparel stores. But take a left on Livernois Avenue and drive several blocks south, crossing Interstate 75, and you'll find the ruins of a once-robust immigrant community, now marked with scarred landscapes, empty buildings and vacant lots.

KOVACS BAR

The Delray neighborhood is easy to find on a satellite map of Detroit: It's just above the charcoal-looking, heavy industrial blob that is Zug Island—and also the sewer plant—southwest of downtown.

By the time you read this, a big chunk of the blighted, pollution-laced neighborhood along the Detroit River will be bulldozed to make way for another bridge to Canada. And any trace of Kovacs Bar will be gone.

One hundred years earlier, this was fertile ground for the American dream. Hungarian immigrants began arriving just after 1900, building a community in Delray. By 1930, Metro Detroit had the fifth-largest Hungarian American population in the United States, according to the *Detroit Almanac*. "Being a Hungarian in Detroit meant, for much of the twentieth century, living in Delray, the working-class neighborhood that was lively from the sound of Gypsy violins but hazy from nearby smokestacks," according to the *Detroit Almanac*.

Kovacs Bar, a two-story red brick building at the corner of West Jefferson Avenue and South Post Street, had remained standing as surrounding properties were leveled and became fields. Its east-facing "Kovacs Bar" sign remained visible, with the faded word "Beer" just underneath it.

Constructed in 1889, the structure started as the Angus Smith Hotel, with a restaurant and beer garden that sold cigars. After Prohibition and some name changes, the building was turned into a tavern by a Hungarian named Micl Kovacs, who'd moved to Detroit from Ohio, according to a 2009 piece John Carlisle wrote for *Detroit Metro Times*.

But after a steady influx of immigrants created a dense, robust neighborhood, the growth of nearby chemical plants, foundries and factories made the area substantially less appealing to residents. Here's what Marco Trbovich wrote for the *Detroit Free Press* in May 1972: "Delray is failing housing and boarded-up stores; it is Zug Island belching filth onto the roofs of houses for so long it's impossible to image what color they were when they were new—which was a long time ago."

Even so, at that time, it drew people across the region to musical performances by Romani people from Hungary and Slovakia. "You know, in the old days Delray was like little Hungary. The best of clientele came in: lawyers, doctors. On Saturdays it was so well lit up, so beautiful. We had gypsies playing in every place. I had tips of $100 bills many times," violinist Alexander Shandor told Trbovich while sipping whiskey at a table one Saturday night in May 1972 in Kovacs Bar.

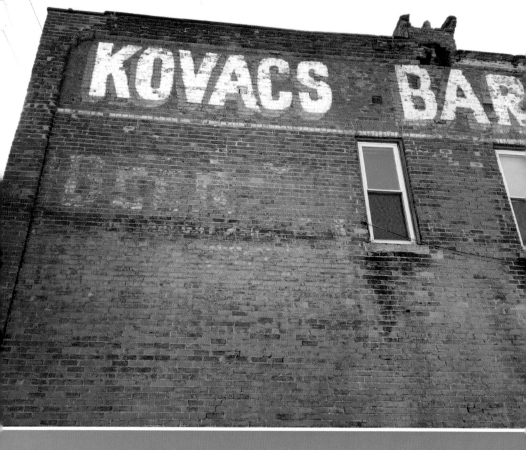

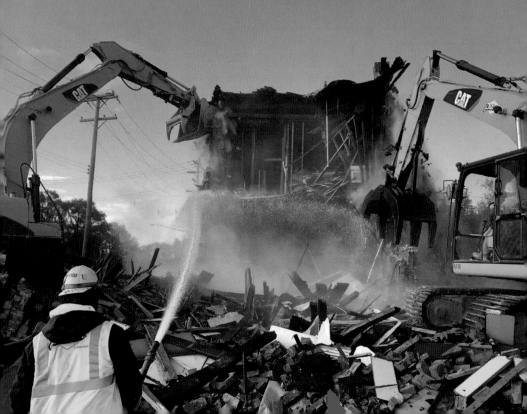

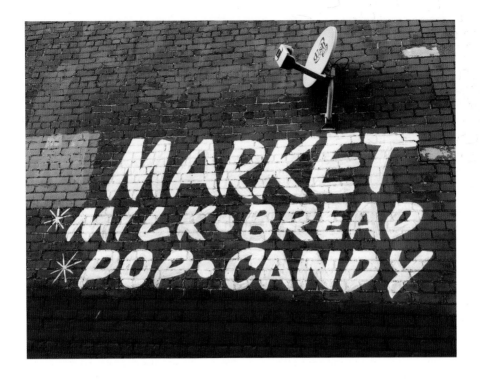

Carlisle visited Kovacs Bar in 2009 when it was still open, being run by a retirement-age couple. He described the interior: "It's undergone few changes in its life. The walls are pine, the ceilings are high, the doors are thick, and the mahogany Art Deco bar is massive. The walnut bar surface itself is made of a single piece of wood, reputed over the years to be the longest one-piece bar in the city."

By then, a trickle of area steel workers appeared to be keeping the place in business, but the owners found themselves frequently in solitude. In August 2017, Kovacs Bar had a liquidation sale, of everything, including the antique bar counter. Among the relics was a vintage "non-combatant" gas mask still in its packaging, old light fixtures, chairs and glassware. "Pretty much if it ain't nailed down...it goes (including some things that

OPPOSITE, TOP The east-facing side of Kovacs Bar shows the bar's name over the faded word "Beer." The building on Jefferson Avenue near South Post Street, including the sign, has since been demolished.

OPPOSITE, BOTTOM Crews tear down Kovacs Bar on November 6, 2017, on Jefferson Avenue near South Post Street. The land is to be used for a new bridge to Canada.

ABOVE The Mi Tiendita party store on West End Street near South Street in the Delray neighborhood had a barricaded entrance in the fall of 2017.

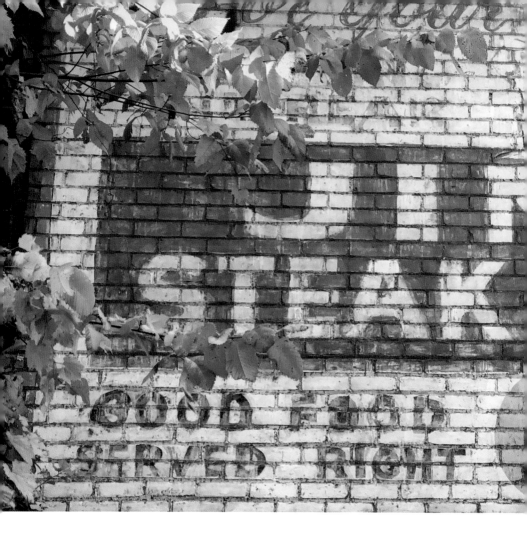

ABOVE A sign for Jim's Steak House was visible on the side of a house across the parking lot from a boarded-up YMCA on Clark Street south of Vernor Highway in the fall of 2017.

ARE nailed down!)," according to the post on Estatesales.net. The post also pointed out that the bar has been used in the making of the films *Hoffa* and *Vanishing on 7th Street*.

That big, historic mahogany bar was purchased by Dave Kwiatkowski, an ownership partner in several of Detroit's newer craft cocktail bars, such as Sugar House and Bad Luck Bar. It's to stay in Detroit, but it isn't immediately clear where it will go, according to *Detroit Metro Times*.

The land Kovacs Bar occupied is planned to become the Gordie Howe Bridge's approach to the United States' port of entry—through

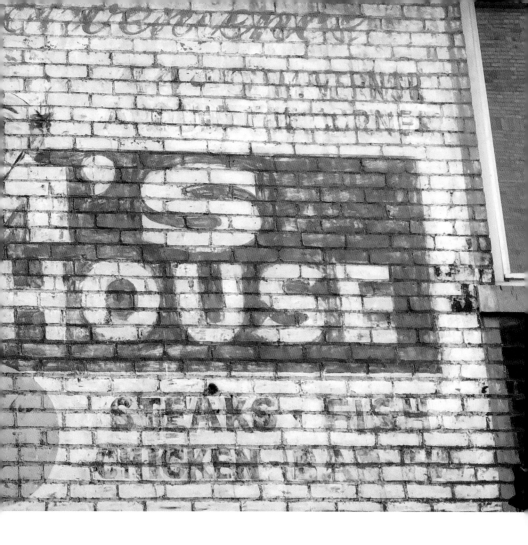

the middle of Delray, according to renderings from the Windsor-Detroit Bridge Authority. The six-lane bridge connecting Detroit and Windsor, Ontario, over the Detroit River, is anticipated to be completed in about 2023, according to a report in the *Windsor Star*. It would provide a third connection between Detroit and Canada and allow for traffic to flow more directly between the border and Canada's highway system.

I first photographed the exterior of Kovacs Bar on May 22, 2017. But the sun was in the wrong place, so I put it on my list of signs to re-shoot. When I returned on November 6, I arrived just in time to see two big yellow excavators clawing the two-story brick building to pieces. The sign painted near the top crumbled through a brownish cloud into a pile of bricks and wood.

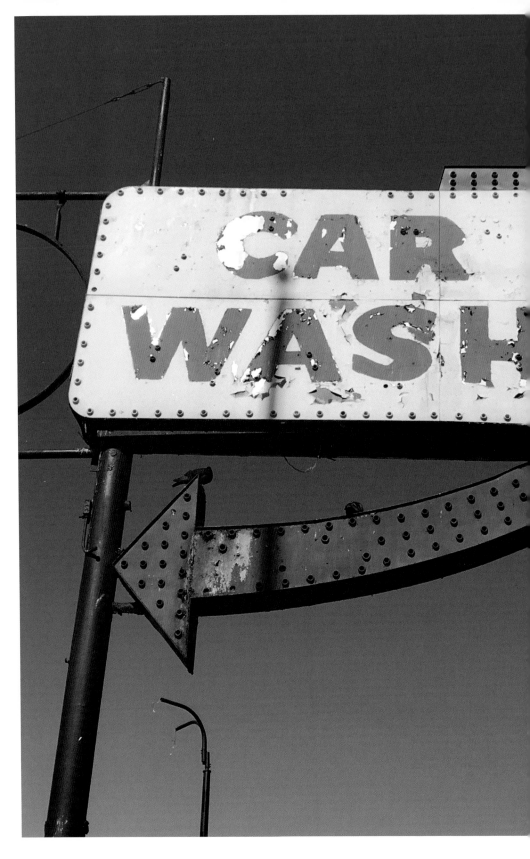

SOUTHWEST FROG LEGS, BASEBALL

FROG LEGS, more than one hundred years ago, were about as easy to find in Detroit as Coney Island hot dogs are today. But they were too popular. "Frogs' legs—the American brand—were invented and patented in Detroit. All others are imitations and infringements," wrote Samuel G. Blythe, Washington correspondent for the *New York World* in a 1905 article published in the *Detroit Free Press.*

He'd visited the city and said the amphibious dish was found at "any first-class restaurant," but the "real places to get them" were roadhouses along the Detroit River. "They bring in the frogs' legs by the platter full, brown and sizzling, as white inside as the snow on a deserted farm, sweet and tender and juicy. You eat frogs' legs until the other end of the table gets into a haze."

A 1907 article in the *Detroit Free Press* boasted that the visitors from out of state found them to be the best available anywhere. Someone from the ocean-side city of Baltimore would "take off his hat to the Detroit frog, for the greenback haunting

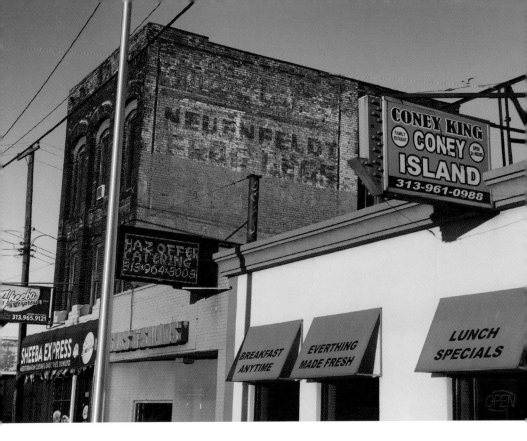

ABOVE A Neuenfeldt Frog Legs ghost sign is visible on the east-facing side of the building housing Sheeba Express on Fort Street at Eighth Street.

the marshes along the shores of the bay lacks that flavor possessed by the fresh water bog dweller."

The legs were so popular in Detroit that an estimated 5 million frogs were devoured annually—with more being exported. And they were usually caught wild. Farmed frogs didn't breed as well in captivity "and are said to lack that rich flavor and delicacy possessed by the swamp-sitter," according to the *Free Press.*

But it didn't last. "Unfortunately, the Detroit and Ontario frogs were loved to death. As early as 1902 hunters were complaining about low numbers, and by 1908, demand exceeded supply; frog legs came from elsewhere," Bill Loomis wrote for *Hour Detroit* magazine in a 2014 article. In 1913, a state legislator from Detroit introduced a bill that was passed into law banning hunting, selling or serving frogs at restaurants from November to June.

In case you're wondering how frogs were hunted, Blythe wrote that he heard a variety of tricks on his trip to the city: "All sorts of explanations were advanced, from the red-flannel lure of our childhood days to the brutal assassination of enticing the unwary frog to the mossy bank of his watery habitat and beating his head off with a vulgar club," Blythe wrote, adding that "if you have never eaten frogs' legs in Detroit, you have something to live for, something for which to strive."

Today, you can still find frog legs for sale, at Sindbad's Restaurant and Marina along the Detroit River on the east side. They come lightly battered and deep fried with two sides for $12.95. For a dollar extra, you can have them sautéed in butter, garlic and white wine.

One of Detroit's former frog leg dealers was at 1366 West Fort Street, on the corner of Eighth Street a little south of Corktown. The sign for Neuenfeldt Frog Market is faded and weather-beaten, facing east on the three-story brick wall. The building still serves food, but frog legs aren't on the menu. Harmonie Express offers Middle Eastern foods such as shawarma and falafel.

Neuenfeldt, when it was in business, offered a variety of meats that helped get Detroit through World War II. Mandatory food rationing limited the amount of meats such as beef and pork that people could buy. *Free Press* staff writer Norman Kenyon in a 1945 article advised people to turn to horse or muskrat: "Many epicures have known right along that fried muskrat can't be topped. Their ranks have been bolstered recently by dozens who keep flocking to the Neuenfeldt Frog Market, 1366 W. Fort," Kenyon wrote. The market also offered opossum, raccoon and turtle meats during the war.

CORKTOWN

From West Fort Street, you can take Trumbull Avenue a few blocks north into Corktown and see Detroit's "oldest surviving neighborhood," according to the Detroit Historical Society. Along the red brick segment of Michigan Avenue, out-of-town visitors to the city frequently stop at the growing number of trendy restaurants and bars.

An influx of Irish people to the city established the neighborhood after a mass emigration from their homeland in the mid-nineteenth century, caused in part by the Irish Potato Famine. "Irish immigrants with enough money to take them beyond the crowded boroughs of New York City and Boston established 'Corktown' in the 1830s. They built detached homes and rowhouses in the Federal style, a reflection of the architectural fashion of the time," according to the Corktown Historic District's entry on the National Park Service's National Register of Historic Places website.

The increasingly affluent residents began to scatter through the city, and by 1900, people from Malta had begun settling the neighborhood. They were followed by Latino immigrants from Mexico and the Southwest who arrived in the 1920s seeking work in the auto factories, according to the National Park Service.

In the 1950s and 1960s, urban renewal efforts and highway construction were among factors that led to the destruction of most of the homes there. About 70 percent of the homes were bulldozed before renovations in the 1990s led to rising property values, according to the *Detroit Almanac*.

DETROIT TIGERS

About one block south of Michigan Avenue, there's a faded blue and yellow sign on Trumbull Avenue that reads "Tiger Stadium Parking; E-Z Out Anytime." The sign claims to have offered parking there since 1933, and it's on a parking lot that remains in use. It's within sight of the longtime former home of the Detroit Tigers baseball team.

For most of the Tigers' history (1896–1999), the team played northwest of the corner of Michigan and Trumbull. The team was first called the Tigers in print by an anonymous headline writer for the April 16, 1895 edition of the *Detroit Free Press*: "Strouther's Tigers Showed Up Very Nicely," according to the *Detroit Almanac*. It kept the name.

Starting with a five-thousand-seat capacity, the field—built on the former site of a city hay market—was initially called Bennett Park for the player Charlie Bennett, who was a fan favorite, Dan Austin wrote for *Historic Detroit*.

Bennett, a catcher, was one of baseball's "greatest artists, one of her truest representatives, a player who stood at the top of his class" before he lost both his legs in an 1894 train accident, according to a *Free Press* article that year. He had played seventeen years, including in Detroit and Boston. "In the old days before the time of catching mits [sic], protectors and masks, Bennett caught more games than any other man, and as a result displays a pair of hands the fingers of which have all been broken twice or more. Knotted and twisted, they are a testimonial to his faithful work," according to the article.

Bennett Park was torn down in 2011 and replaced with Navin Field, which started with twenty-three thousand seats, Austin wrote. By 1935, the capacity had been expanded to fifty-three thousand, and it was renamed Briggs Stadium. In 1961, the name was changed to Tiger Stadium. "More than 11,000 home runs were creamed at the Corner. Babe Ruth and Mickey Mantle hit the longest dingers of their careers at the stadium," Austin wrote.

The team hosted its final game there on September 27, 1999, before moving downtown to Comerica Park. Tiger Stadium was demolished in 2009.

For about fifteen years, the site was dormant. But in the spring of 2016, heavy machinery broke ground near home plate to build the headquarters for the Detroit Police Athletic League, a mentorship and sports youth

program. The headquarters is to be open by the time you're reading this, and development around the field is to also include retail and housing space, according to an article in the *Detroit News*.

On game days, Tigers fans often still park in Corktown, with Nemo's Bar and McShane's Pub and Whiskey Bar offering shuttles to Comerica Park a little more than a mile east.

By the mid-2010s, the increasingly hip neighborhood had become a must-visit destination, and sites from the hulking, empty Michigan Central Station to award-winning restaurants were featured in international travel articles. A craft distillery and two craft breweries opened, as did a wine bar. But the Irish influence remains, and you can still drop into places like McShane's or the Gaelic League of Detroit among several other joints offering a Guinness and a shot of Irish whiskey.

LEFT The Tiger Stadium Parking sign, offering parking since 1933 at 1750 Trumbull, is visible southeast of the former Tiger Stadium site in Corktown.

NANCY WHISKEY PUB

The most famous of these is Nancy Whiskey Pub, which calls itself "Detroit's. Oldest. Party. Established in 1902!"

Separated from the Corktown strip by Interstate 75, the bar is at the corner of Spruce and Harrison Streets, surrounded by houses, some in a better condition than others. There's live music on the weekends and a big party on St. Patrick's Day. Among its menu items are fish and chips (as seen in a Long John Silver's commercial featuring the pub), corned beef sandwiches, burgers and a decent variety of fried bar food. The *Washington Post* featured the bar among eight deemed "America's Most Authentic Dive Bars" in an article: "Nancy Whiskey's history is a microcosm of Detroit in the twentieth century. The Irish bar, a converted general store tucked away on a side street of the historic Corktown neighborhood, got its liquor license in 1902. It survived Prohibition, allegedly as a speakeasy. When the city's economy roared, it became a hangout for Teamsters, including former union president Jimmy Hoffa, who used a phone booth near the front door to conduct private business."

The *Post* also mentioned the October 2009 electrical fire that severely damaged the first floor, closing the bar for nearly a year: "Restoration became a community effort: A regular who teaches wood-shop class at a high school built the bar counter; the daughter of another regular painted the pressed tin ceiling."

In a city experiencing a wave of craft cocktail bars and breweries opening, it's good to see people caring for storied dive bars. Meanwhile, longtime Detroit watering holes, such as Kovacs Bar in the previous chapter and Steve's Place in the next chapter, are disappearing.

OPPOSITE, TOP Nancy Whiskey on the southeast corner of Harrison and Spruce streets declares itself "Detroit's Oldest Party."

OPPOSITE, BOTTOM A sign for the former John Sobieski Wholesale Meats is visible on Michigan Avenue west of Eighteenth Street.

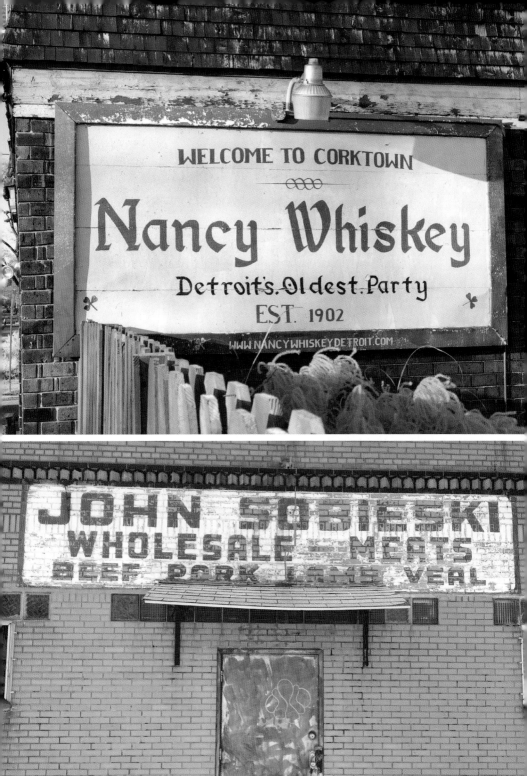

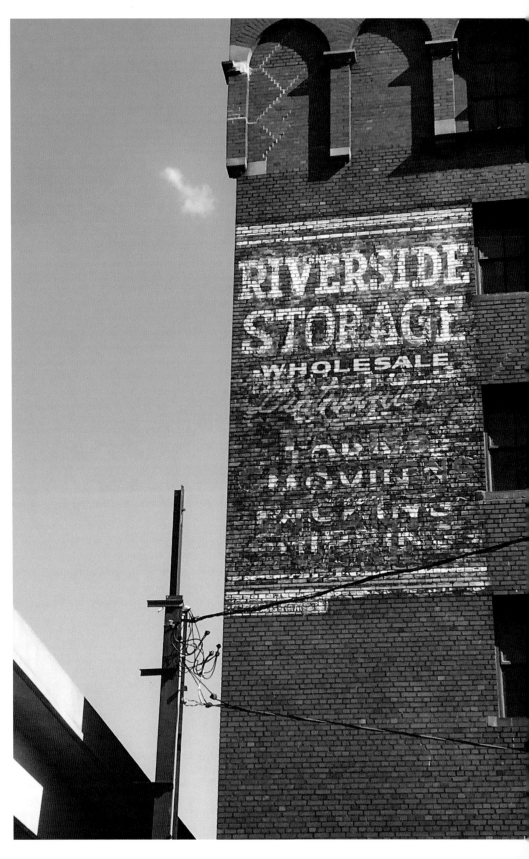

DOWNTOWN

UNLIT HIGH-RISES, splintered storefront windows and empty liquor bottles blighted blocks of downtown Detroit as recently as 2013. Nights and weekends when no ballgames or events were scheduled, it was dreary quiet—interrupted by sudden shouts of bickering drunkards and the dull moan of the empty People Mover's two-car train, echoing around the buildings, between stops for nobody. At winter's peak, you might wobble, trying not to slip on a sidewalk that nobody shoveled—snow, hardened into ice, covered in bumpy footprints.

I met Chris Jaszczak, a decades-long resident, on Broadway Street near John R Street in the fall of 2014. He'd lost running water to his loft and downstairs café because conditions were too dangerous for city workers to repair an underground waterline

LEFT A sign for Riverside Storage is visible next to the Detroit People Mover in downtown along Cass Avenue north of Congress Street.

leak in the rear alley. So the city rigged up a garden hose to a fire hydrant using a PVC pipe and duct tape. It was hooked up that way for months because conditions in the alley below tall, crumbling buildings were too dangerous for ground-shaking excavation work. Employees of the 1515 Broadway café and small theater he operated called it "Death Valley," fearing they'd get clunked in the head with falling debris. They boiled water before making coffee to make sure it was safe for human consumption. In the upstairs loft, buckets collected rainwater near Jaszczak's bed. Bricks, falling off the next-door building, had smashed holes in his second-story roof.

The bricks were pieces of the fourteen-story Wurlitzer Building. The Wurlitzer family, famed piano-makers, constructed it in 1926. Powerful Wurlitzer organs in that era could be heard from Detroit's Fox, Fisher, Michigan and State Theaters, according to *Historic Detroit*. The narrow, rectangular Renaissance Revival–style building once included floors of musical instruments, radios, turntables, audition booths and more. By the 1970s, the Wurlitzer company had left the building, and it was partially occupied by various businesses and organizations. In the early 1980s, "the few tenants the Wurlitzer had soon moved out, saying they had no choice after suffering long enough through the winter without heat or running water," while the owner said he was having financial problems, according to *Historic Detroit*.

RIGHT The Hotel Fort Shelby sign remains visible on a building now occupied by the Fort Shelby Residences and DoubleTree Suites by Hilton Hotel Detroit Downtown on the southwest corner of West Lafayette Boulevard and First Street.

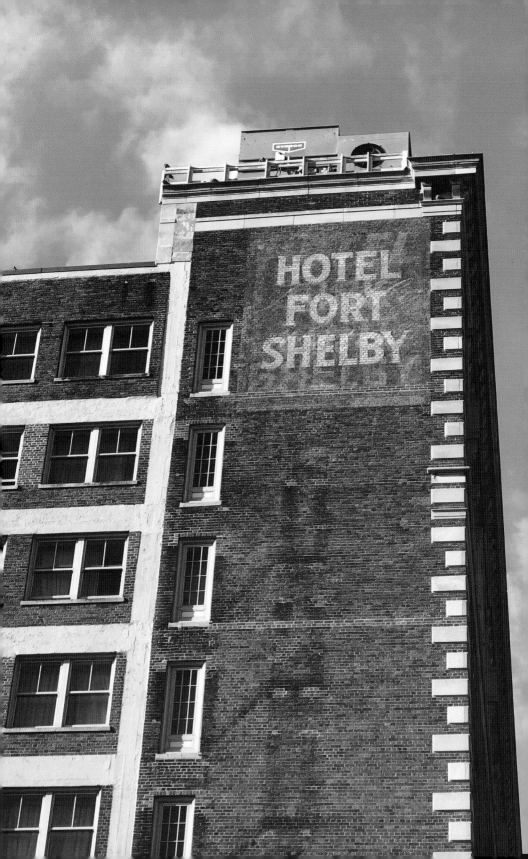

For decades, the building decayed. A sign outside the blocked-off entrance by 2014 offered "Free Coffee* with purchase of Wurlitzer building," with the disclaimer "*see above for details." The tongue-in-cheek advertisement brought attention to the building's horrid state as people visited Jaszczak's café. Since then, improvements to the Wurlitzer and nearby Metropolitan Building led to a permanent fix for the water problem. The Wurlitzer's bricks were secured. The holes were filled in. And by the fall of 2017, the Siren Hotel was anticipated to soon offer 106 guest rooms, "seven food and beverage spaces, two retail boutiques, and a rooftop with panoramic views of the city spread across 55,000 square feet," according to *Curbed Detroit*.

This is one example of dozens across downtown Detroit, where revitalization has accelerated since the city emerged from its historic bankruptcy in December 2014. Billionaire businessman Dan Gilbert spurred the momentum since he moved his Quicken Loans headquarters from Southfield to downtown Detroit in 2010. By 2016, about 3,100 of its employees were living nearby. Other businesses followed, including Microsoft, which in 2017 moved its Technology Center from Southfield into forty thousand square feet of the One Campus Martius building on 87 Monroe Avenue, as John Gallagher wrote in a February 2017 *Detroit Free Press* article. "Speaking to a pep-rally type event in the One Campus Martius building, Gilbert said that Detroit was 'at the intersection of muscles and brains' making advances in both automotive technology and financial services technology—car tech and fin tech—and would become a world capital of technology in 10 or 15 years," Gallagher noted.

By late 2017, lights were on inside the David Stott Building (thirty-two floors), Book Tower (thirty-eight floors) and Detroit Free Press Building (fourteen floors), all of which had been dark, vacant and deteriorating. Crews had begun renovation work soon after Gilbert and his associated business entities purchased them. The *Free Press*, which had sold its former building and moved in 1998 to the Detroit News Building a few blocks away, moved with the *Detroit News* in 2015 into the Federal Reserve Building on 160 West Fort Street—also owned by Dan Gilbert's businesses. The People Mover continued its circuit through downtown, joined in mid-2017 by Gilbert's QLine streetcar system connecting downtown to New Center, a 3.3-

mile route north and south. Virtually all the splintered windows along Woodward Avenue, and several other areas, were replaced. Storefronts such as Bonobos menswear store, a Nike Community Store and Avalon International Breads café and bakery opened.

The rapid change drew fresh energy to streets and sidewalks, which increasingly became snow-shoveled and salted in winter. Nights and weekends became opportunities to explore new downtown restaurants and try craft cocktails, such as a cucumber margarita (nine dollars) at the Skip—tucked in an alleyway below the Z Park parking garage—or a Crow Joe (ten dollars), made with hand-crafted vodka, house-made coffee infusion, cinnamon syrup and cream at the Rusted Crow Detroit Gastrolounge on Adams Street.

But the fresh developments have forced some longtime residents to relocate. The Albert "luxury apartments" in Capitol Park, on December 16, 2017, offered a 746-square-foot, one-bedroom apartment on the sixth floor for $1,685 per month on a twelve-month lease, according to its website. In downtown Chicago, that would be a fantastic deal. In Detroit, where the median household income in 2016 was $26,249, it's unaffordable to most people—such as, perhaps, the ones who lived there a few years earlier. The twelve-floor apartment building had previously been the Griswold Apartments, where more than one hundred low-income senior citizens lived. The building's conversion "into market-rate apartments is the example of gentrification that comes up in conversations again and again," as Nancy Derringer reported for *Bridge Magazine*. Her article points out that the previous residents received relocation help through a nonprofit but that the community they had was "in one fell swoop of capitalism, atomized, for people willing to pay over $2 per square foot of chic living space."

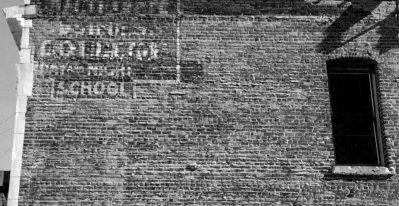
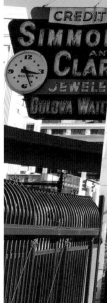

"THE GREAT
ROLLER COASTER RIDE"

Simmons & Clark Jewelers weathered both the Great Depression and Great Recession in downtown Detroit. As the buildings around it became revitalized, this business completed its own renovations in the spring of 2017.

The jewelry store opened in 1925 and moved to its current location in 1934. In a 1942 advertisement in the *Detroit Free Press*, it offered a three-diamond solitaire ring for $37.50 (about $584 in 2017 dollars), or in installments of $1.25 per week. "Out of the High-Rent District, You Save at Simmons & Clark Jewelers," according to the advertisement.

"It's where it actually started—in Detroit, buying jewelry on credit," owner Michael Simmons told *Crain's Detroit Business* in an April 2017 article, reflecting on the business's ninety-two-year journey. "Dad would term it 'the great roller coaster ride.'"

Simmons in December told me that things continue improving, "but we still need more people working and, especially, living downtown. People's attitudes are very different toward the city, and I hear it every day from my vendors, asking what is going on after reading articles about the city."

If you're standing on the sidewalk a little north of the building on 1535 Broadway Street, several ghost signs are visible on brick. On the jewelry store wall, one says "Electric Irons and Heating Devices." The one just above it is more difficult to decipher, except for the words "Day and Night School."

These two signs predated the jewelry store at the building, which was constructed in 1922. Simmons said they became exposed when the Madison Theatre storefronts were demolished in the early 2000s. From 1922 to 1934, the building had been home to Boyer's Auto Supply and Dave's Auto Supply.

Above and behind the jewelry store wall are larger advertisements for the adjacent Hartz Building: "Since 1897— The Home of Hartz Vitamins [and] Surgical Appliances." But since 2003, it's been a good place to find a craft beer. Detroit Beer Company, a microbrewery and restaurant, is a hangout for nearby residents, and it gets especially crowded on days the Detroit Tigers are playing at nearby Comerica Park.

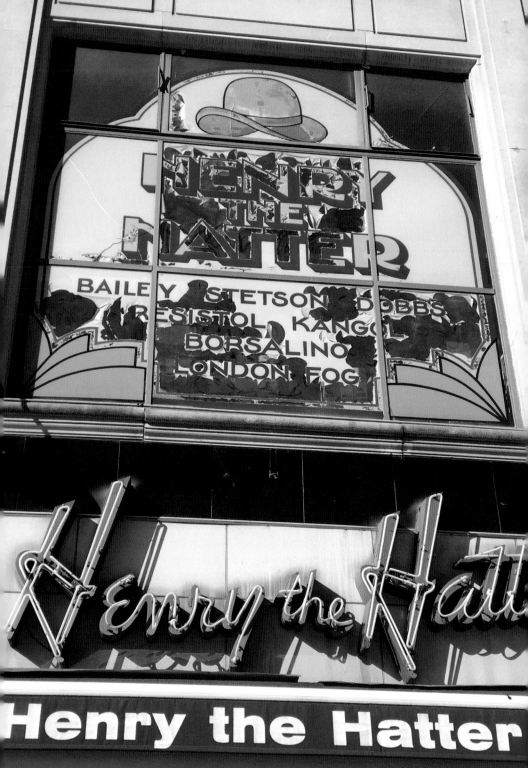

HENRY THE HATTER

BAILEY · STETSON · DOBBS
RESISTOL · KANGOL
BORSALINO
LONDON FOG

Henry the Hatter

Henry the Hatter

HENRY THE HATTER

Walk a few blocks south of the jewelry store and, until recently, you'd find a business calling itself the oldest hat retailer in the United States. Henry the Hatter was founded in 1893, and celebrities from President Dwight D. Eisenhower to comedian Steve Harvey along with rock stars such as Jack White and Kid Rock have worn its hats. Styles included felt dress hats, straw hats, pub caps and many more.

Owner Paul Wasserman said that business by 2017 was the best he'd seen it since the late 1970s, even despite the rise in megastores and online shopping. But the building's property owner forced him out, he said. In August 2017, the location closed after sixty-five years in downtown Detroit.

With three signs, each in different styles, the property at 1307 Broadway Street was tough to miss. In glass above the entrance was an adhesive sign in tatters. It contained a bowler-style hat over green lettering, along with a list of brands, such as Stetson and London Fog. Below that, there was a neon sign reading "Henry the Hatter" in cursive and, at the bottom, a basic vinyl sign with white letters.

For a few months after the location closed, only the remaining store in Southfield was in business. But in December 2017, the downtown store moved to Eastern Market, occupying a space formerly used by a pet accessories store. Wooden showcases from the downtown location were deconstructed and used to line the walls of the new place. Also, the neon sign made the trip, as reported in the *Detroit News*.

So while the downtown location, as pictured in this book, no longer exists, you can still see the sign at 2472 Riopelle Street. Henry the Hatter has been in Wasserman's family since his father, Seymour (Sy) Wasserman, purchased it in 1948 from founder Henry Komrofsky. Just about every Detroit mayor, except Mike Duggan, has been inaugurated in a hat from the store since Wasserman has been there, he said.

In the late 1980s, after downtown Detroit's massive Hudson's department store was demolished, Henry the Hatter was the only operating business on the block. A loyal customer base helped Wasserman stay in business through the city's tougher years, he said.

With demand growing for downtown properties, it's likely something else will soon occupy this storefront. It's not likely that tenant will have as deep of Detroit roots.

LEFT The neon sign visible on this former location for Henry the Hatter on 1307 Broadway Street in downtown has since been moved to 2472 Riopelle Street in Eastern Market.

JOHN K. KING USED
& RARE BOOKS

Detroit's most famous bookstore operates in a former glove factory on the western edge of downtown. Narrow aisles, framed by wooden shelves on wood floors, are stuffed with books. Some fill plastic crates and cardboard boxes. Tables are covered with them. There's no computer system. When you walk in, an employee will offer you a paper map of the four floors, broken down into sections—from hardcover mysteries to magic, freemasonry, Civil War, auto manuals, railroads and dozens more.

The store's website acknowledges the unconventional, non-digital format: "However, we find this does create a unique book-shopping experience that encourages getting lost in the aisles. Don't worry, we'll gently push you out at closing time."

John King, the owner, opened the store in 1983, when the area was much quieter. "It was like a desert: There was nobody around here. It was really cool," he said, chuckling. "I liked it."

He said he'd always intended it to be a destination store. And that's what it's become. The day I interviewed him, a large passenger van was parked outside. I asked which group was visiting. He wasn't sure. The huge bookstore—with a red, neon-lit window sign boasting "1,000,000 books"—has continued business more than thirty-four years, some leaner than others. "We're tenacious," King said. "We try and supply people with rare books, and we work hard at it, and we play fair, and we don't cheat people. And so, we continue on our path here."

RIGHT The glove symbol from Advance Glove Manufacturing Company remains intact on a building occupied since 1983 by John King Used & Rare Books on West Lafayette Boulevard west of the John C. Lodge Freeway.

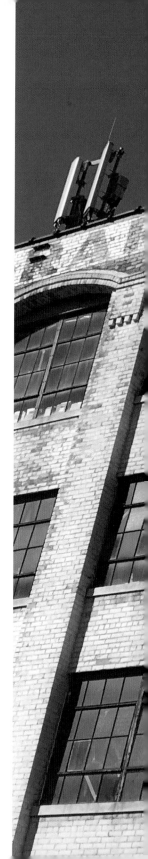

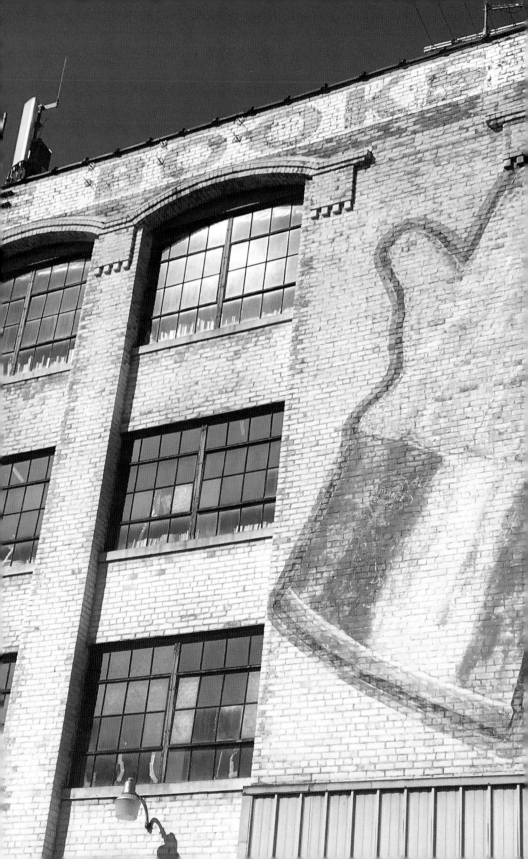

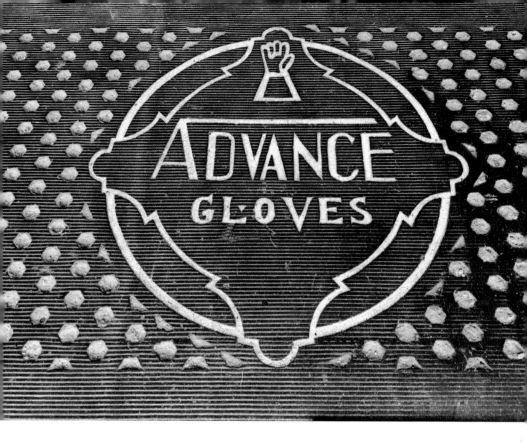

Other bookstores have added coffee shops and greeting cards among efforts to entice customers. King calls that "just totally moronic," and he sticks to selling books.

In November 2003, Borders Books and Music opened a downtown Detroit location in the Compuware Building at Campus Martius Park. King said many people claimed that the highly publicized move would revive the city, but it didn't. Associated Press writer Mike Ramsey quoted the Borders location's sales manager musing on customers in a 2004 article: "They say, 'Oh my God, I can't believe it's a bookstore in downtown Detroit.'"

King received a copy of the article from a friend in Philadelphia, who'd circled the quote. "And I'm going, 'Fuck you,' you know, in my head, because that was so evil," King said. "But the thing is, I tell people now, 'I was here before Borders, I was here while Borders was here, and I'm here after they croaked—after they're dead, I'm still here.' But that was such an irritating quote, I'll never forget that."

Borders announced its plans to close the Detroit location in January 2009, as the Ann Arbor–based bookseller suffered declines, the *Detroit News* reported. The company went out of business in 2011, but John King Books continues to thrive. King said his in-store sales have lately been increasing. He's owned bookstores since the 1970s, and there's also a John K. King Books North in Ferndale.

At the Detroit location, evidence of the building's former life as a glove factory is noticeable the moment you walk in the door: King has kept the same floormat, which reads, "Advance Gloves" and includes the image of a glove. And you can't miss the glove painted on the building's exterior.

The Advance Glove Manufacturing Company had previously been a massive enterprise, producing millions of gloves, many of which people wore in World War II to make guns, tanks and other armaments. "Production of gloves for men 'fighting on the production front' at the plants of the Advance Glove Co. flows from three busy factories, in which about 85 per cent of the employees are women," the *Detroit Free Press* reported in 1942. Below the story, an advertisement of "Gloves for 'FIGHTIN' MEN'—in BOTH Armed and Working Forces" from the glove company emphasized its support for the war effort: "Every man, every woman, every machine, every square foot of ground and factory space in our plants is dedicated to VICTORY'S cause. We can do nothing else. We would not want to do anything else."

The types of gloves included canvas, leather, asbestos and steel grip. The company was founded in 1930 and included plants in Toledo and Chicago, as well as its home office in Detroit. It moved into the 901 West Lafayette Boulevard location—now occupied by the bookstore—in about 1941, the *Free Press* reported.

King said that by the time he moved in, the place was "abandoned, pretty much." The fire sprinkler system's pipes had frozen and blown up. Flooded floors had to be repaired, and holes in windows were fixed. He said he kept the glove image on the side of the building because people recognize it. "I mean, everyone always mentions the glove. So we decided, 'Well, since everybody recognizes it, I don't want to destroy a historical artifact," King said. "Some guy wanted to paint a book in the glove—you know, holding a book. But we didn't go for that."

STEVE'S PLACE

Opening the door to this bar in downtown Detroit's Bricktown, you kind of felt like you were intruding, as though it was already past closing time. It was quiet, dimly lit and chilly in winter.

The octogenarian owner Steve Francis—or Mr. Steven, as we long assumed was his name from the big sign on the building's east side—would kindly smile and offer you a free shot of schnapps. He was "a charming, grandfatherly, Old World gentleman who still wears a tie and a checkered shirt to work every day, who hitches his baggy trousers high, who glides in little shuffles across the floor in scuffed dress shoes," as John Carlisle described Francis in a 2012 piece for *Detroit Metro Times*.

The bar in a long, narrow building was a world—or at least several generations—away from the bulk of downtown Detroit's energized craft beverage scene in 2017. Dusty decorations including streamers, old lunch boxes and a long-defunct food menu lined the walls for perhaps decades without being touched. The cash register was a big old hunk of metal. It was a place you could go with a few friends and have a few rounds of semi-cooled Pabst Blue Ribbon bottles, and when it came time to settle up, Francis would do the math in his head. And it seemingly always came to fourteen dollars, cash only. Meanwhile, his wife slept in a booth, keeping warm under blankets. They had a hard time affording heating. If you wanted entertainment, you could plug in a jukebox and hear songs from the 1980s and 1990s. This was the scene in 2015 as the bar was dimming out. Steve's Place was next door to the St. Andrews Hall music venue, and newspaper ads from the 1980s and 1990s showed the bar as frequently hosting live blues bands.

Francis was born in 1924 in Oregon and raised by his family in Greece, surviving the German occupation in World War II and later serving in the military during the country's ensuing civil war, Carlisle wrote in a 2015 article in the *Detroit Free Press*. Francis bought the bar in 1972, having waited tables at the Caucus Club and London Chop House until he'd saved enough money. He and his wife, Sophie, took turns running it into their later years, living in an apartment above the bar. "With him dies one of the last remnants of old Detroit—a tougher, grittier place that predated the glitz of the nearby casinos that dwarfed his little bar and the cocktail lounges that sprang up around him and rendered his place supposedly boring by comparison," Carlisle wrote for the *Detroit Free Press* on June 24, 2015, reporting on Steve Francis's death at ninety.

"TEMPLE OF SHOES"

An off-white, fourteen-story Neo-Gothic building with tiny, gnome-like gargoyles stands at the north end of downtown on the corner of Woodward Avenue and Adams Street. Bluish and greenish block letters on the north- and west-facing sides read "Fyfes Shoes."

Today, it's full of apartments. When it was built in 1919 over a former cemetery, it was the world's largest retail shoe store, the *Detroit Free Press* reported in 1917. It was named for one of Detroit's first cobblers, Richard Henry Fyfe, who arrived in Detroit at age sixteen in 1855.

Business peaked in about 1950, when 150 people worked there. With 100,000 pairs of shoes in stock, hundreds of them were shipped daily across the world, according to the Detroit Historical Society. The building's ten stories, four mezzanines and two basements included more than shoes: there was a children's barbershop, a playroom, places to repair and shine shoes, an in-house foot and shoe specialist and an auditorium. "A miniature golf course on the fifth floor and a merry-go-round in the second-floor children's department once lured hundreds of Detroiters and tourists a day to the 'Temple of Shoes,'" according to a 1971 article in the *Free Press*.

When Fyfe first arrived in Detroit, he found a job at a shoe store he would later buy. He didn't have much money, and he'd sleep on the floor in the back of the shop, where he made about two pair of shoes per day by hand. He founded R.H. Fyfe Company shoes in 1865, and he became known to peers as a man who pioneered the retail marketing of shoes on a large scale. Earlier, shoemakers went from house to house, making and repairing shoes for family members. Fyfe's store on 183 Woodward Avenue was destroyed in 1917 in a major fire that killed five firemen. "The next day, Fyfe's fire sale topped all records for attendance. Mounted policemen were called out to control the shoppers," the newspaper reported.

OPPOSITE Signs for Fyfe's Shoes are visible near the top of the fourteen-story Fyfe Apartments on 10 West Adams Street.

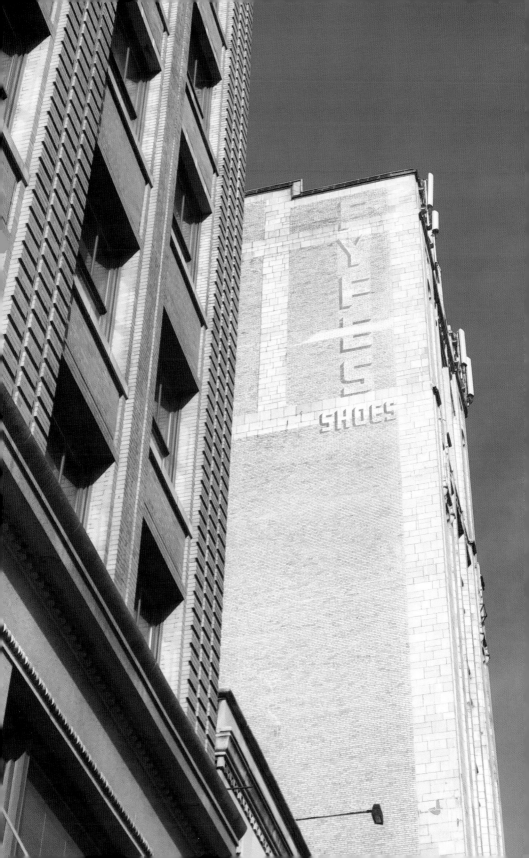

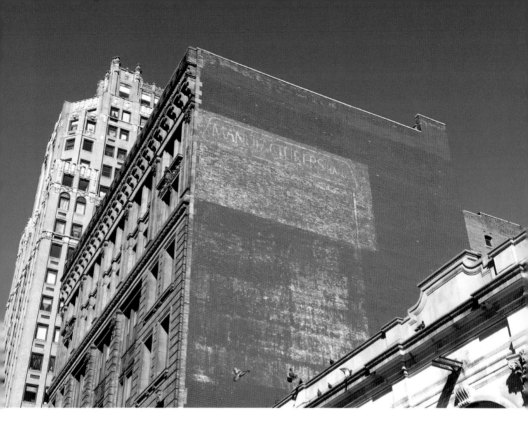

ABOVE A ghost sign for Manufacturers Bank, which was eventually sold to Comerica Bank, is visible on a building along Washington Boulevard south of Grand River Avenue.

In 1919, the new home for the business was the tower constructed on the northwest corner of Woodward and Adams, across the street from Grand Circus Park. Fyfe's obituary, after he died at ninety-two, was front-page news on October 28, 1931. He was described as a well-respected, highly connected businessman integral to the city's history who owned what was believed to be the largest retail shoe store in the United States. "Richard Henry Fyfe's biography is a history of Detroit from oxen to airplane. It is a story of a city growing out of one size shoe after another and the many men who fused their initiative and pooled their vigor as they made for themselves and their city a place in the eyes of the world," according to the obituary. "'I've come to the gate,' he said Friday, rousing out of a heavy sleep. 'Beautiful! Beautiful! I'm very tired and ready to go.'"

The company never expanded its presence beyond Detroit, and in the coming decades, an aging customer base that then lived in the suburbs became "afraid to come downtown," the *Detroit Free Press* reported in 1971. The building would soon be renovated into apartments. In the summer of 2014, I moved into a one-bedroom unit on the twelfth floor. It was a modest place, with a small kitchen and tall windows—with the original, heavy metal frames and big latches—from which you could see the Detroit Tigers playing on the scoreboard to the east and even a small part of the Detroit River to the south. Extra-long curtains were necessary to keep the sunrise and the blinding Comerica Park stadium lights out of the bedroom.

Detroit was in bankruptcy at that time. In winter, I'd look out my window to see destitute people in sleeping bags, placed over the steam rising from vents in the streets, as they sought to avoid hypothermia. The Fyfe's ground-level commercial space was vacant, like many storefronts along Woodward Avenue I'd pass on foot as I commuted several blocks to work at the *Free Press*. I normally had the wide sidewalk all to myself. But the Fyfe Building was full, with a diverse mix of tenants including longtime residents, families and single millennials. In the next few years, a steady number of apartment buildings and condominiums would open nearby. In the fall of 2017, a party store opened on the Fyfe's ground. The QLine streetcars began operating along Woodward, and within a block, at least two vacant high-rises—the David Whitney and Briggs Houze—now had people living in them.

LOYAL ORDER OF
MOOSE LODGE

This building is surrounded by parking lots at the northwest end of downtown Detroit, at the corner of Cass Avenue and West Elizabeth Street. The word "Dancing" is barely decipherable on its west-facing brick wall.

It opened in 1922, according to *Historic Detroit*. Like the nearby Masonic Temple and Grand Army of the Republic buildings, this one reflects times in the early twentieth century when social clubs and secret societies were especially popular. It's unclear whether the faded brick sign advertised activities here or someplace else. Given the wide-open space surrounding it by 2017, this was arguably the bleakest part of downtown Detroit at the time. It really only saw action when people tailgated for Detroit Lions games. But its most-desolate days could be behind it. The decades-vacant Moose Lodge building was purchased for $1.5 million in February 2007 by the Ilitch family, who founded Little Caesars Pizza and owns the Detroit Tigers and Red Wings. The Ilitches' Olympia Development filed with the state in August 2017 calling for asbestos cleanup, indicating plans for rehabilitating it, according to *Historic Detroit*.

Across Interstate 75 to the north, the Ilitch-owned Detroit Red Wings moved into Little Caesars Arena in the fall of 2017, and commercial and residential developments are underway surrounding it. Also in the fall of 2017, the Detroit Pistons moved from Auburn Hills to the new arena, making Detroit now a city with all four major sports teams playing within city limits. Just across Grand River Avenue south of the Moose Lodge building, Beacon Park opened in the summer of 2017. This 1.2-acre public space developed by DTE Energy includes an open lawn and restaurant with rooftop garden.

RIGHT A sign advertises dancing on the side of the Loyal Order of Moose Lodge building at the northwest corner on Cass Avenue and West Elizabeth Street.

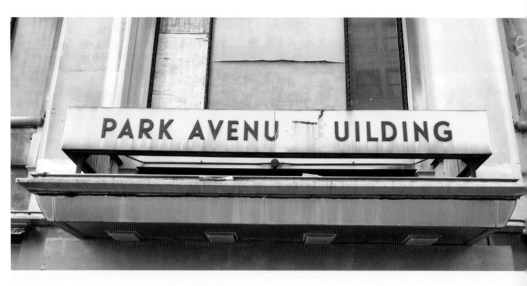

PARK AVENUE BUILDING

The twelve-story Park Avenue Building on the corner of Adams and Park was nearly destroyed in 2014. The city ordered demolition of the office building because of dangerous conditions such as a loose fire escape and crumbling bricks. An out-of-court agreement with the building owner, Ralph Sachs, was reached, requiring improvements to make it safer, according to the Preservation Detroit website.

Long vacant and in rough condition, the 102,000-square-foot structure at the northwest corner of Grand Circus Park was built in 1922 and was designed by famed Detroit architect Albert Kahn. Among the many businesses inside were "McGill & Wind: Makers of Good Clothes for Men" and Wellman, which sold fur garments made from raccoons, muskrats, moles, squirrels, lambs, Alaskan seals, leopards and more, according to a newspaper advertisement on Christmas 1929.

The future of the Park Avenue Building remains uncertain. It was listed for sale in 2017 after Sachs, who had owned it since 1981, died at age seventy-six, according to *Crain's Detroit Business*. The former Briggs Hotel, which is directly next to the Park Avenue Building to the west, opened as Briggs Houze apartment building in late 2016.

ABOVE The decaying sign for the Park Avenue Building is seen on the northwest corner of Park Avenue and Adams Avenue.

CAPITOL PARK

This half-acre triangle of concrete and brick, interspersed with boxes of trees and grass patches in downtown Detroit, is both a key site in Michigan's history and, as of 2017, perhaps the city's most striking example of rapid improvements.

"Here is where Michigan first assumed its full and equal station in the union of American states. Here is where escapees from human bondage found shelter and first glimpsed freedom. And here is still found the grave of Michigan's first governor," as Jack Dempsey wrote in the magazine *Michigan History*.

Capitol Park, surrounded by old, tall buildings, is a little bit north of Michigan Avenue and west of Woodward Avenue. When Michigan gained statehood in 1837, a building here was designated the capitol. But when the state reached a self-imposed deadline of 1947 to set a permanent capitol, legislators argued to move it inland to "increase the defensibility of the capital by moving it away from the Canadian border," promote settlement, boost the economy of the state's interior and make it more accessible to people across Michigan, according to the Michigan State Senate website.

"Debate turned to bickering and, eventually, into deadlock. Many names were presented as a joke, including that of Copper Harbor at the northern-most tip of the Upper Peninsula," according to the website. The legislators compromised, and today Lansing is the state capital.

In 1850, the Finney Hotel and horse barn opened on Griswold across from the former capitol building. "The barn became a 'passenger depot' on the Underground Railroad; for a decade, it served as a hiding place for runaway slaves attempting to cross the Detroit River to freedom in Canada," Dempsey wrote.

The oldest surviving high-rise building in Detroit is the Detroit Savings Bank Building, at the northeast corner of Griswold and State. The building was constructed in 1895 and called the Chamber of Commerce Building before the bank purchased it in 1915 and renamed it in 1921, according to *Historic Detroit*.

Michigan's first governor, Stevens T. Mason, was twenty-five when he took office in the 1830s. He's the youngest governor in American history, Dempsey wrote. And today you can visit his grave at the Stevens T. Mason Monument at Capitol Park.

If you were standing in front of the memorial in 2013, you would have been able to see a strip club to the north, colorful graffiti marking up the Farwell Building to the west, a party store offering to accept food stamps to the east and unoccupied storefronts in virtually every direction. Four years later, everything's changed. The strip club, on Griswold Street near Grand River Avenue, was destroyed in a fire in 2014 and has since been replaced with a thirteen-story micro-apartments building

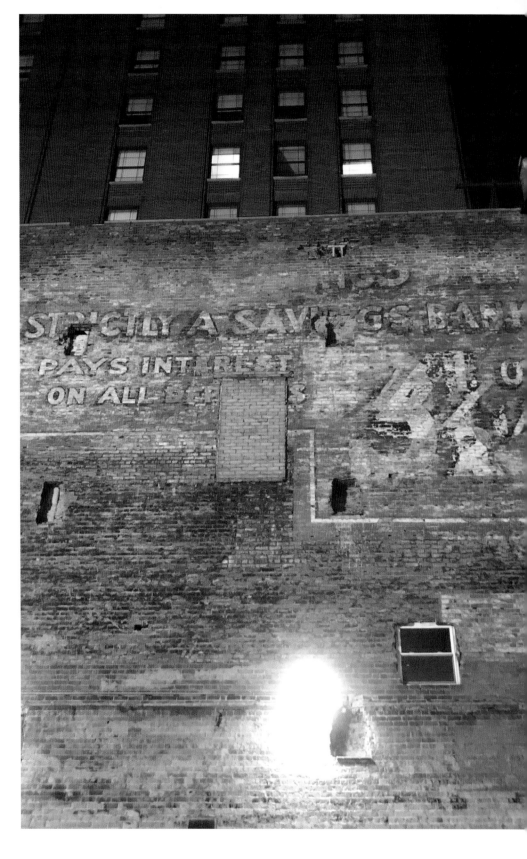

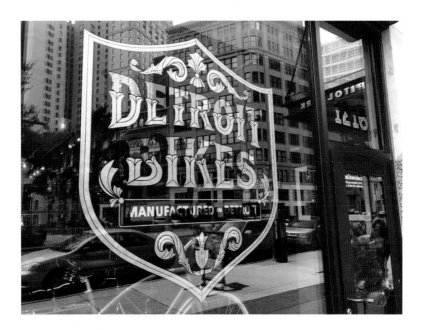

LEFT A weathered ghost sign for the United Savings Bank of Detroit remains visible on a building along Griswold Street south of Grand River Avenue in Capitol Park.

ABOVE The gold-leaf sign for Detroit Bikes welcomes customers to the bike store operating at 1216 Griswold Street in Capitol Park.

(260 square feet for one unit). The party store closed, the space was renovated and now there's a health clinic in part of the building it occupied. Here's what else opened: a nail salon that also serves wine, a coffeeshop, a Thai restaurant, a pizzeria, a high-end steakhouse, an upscale cocktail bar, a pet boutique and a women's clothing store. Travel writers frequently remark about Detroit Bikes, a shop that sells made-in-Detroit bicycles starting at about $600. The company was founded in 2011, and its Capitol Park location opened in 2015.

THE FARWELL BUILDING

Graffiti, mostly incoherent letters in different fonts and colors, covered many of the windows across eight floors of this building for years. Trees grew on its roof. But by late 2017, the years of deterioration had largely been reversed. I first photographed the faded sign on the south side of the Farwell Building in the springtime. A few months later, the sign had been repainted—mostly in the same style with some added flair and the addition a ".com" under the word "Farwell." Most if not all the windows had been replaced. Previously an office building on the west side of Capitol Park, the Farwell Building opened on March 8, 1915, Dan Austin wrote on the *Historic Detroit* website.

"Named for Jesse Farwell, a man who made his fortune in real estate and shipping among other fields, the building was built for mixed office space use and was home to attorneys, dentists and other professionals," Austin wrote.

It was added to the National Register of Historic Places in 1976. By the mid-1980s, after losing tenants, the building was closed. Through the decades, it was frequented by urban explorers—and scrappers. "The vaulted dome of the lobby was inlaid with thousands of Tiffany glass pieces. Each piece of Tiffany glass, or as Tiffany named it, favrile, was individually cut and polished. The sheen of the ceiling resulted from a backing of gold leaf," Austin wrote.

Louis Comfort Tiffany was a highly respected American stained-glass artist and designer from the late 1800s to early 1900s, and these are treasured examples of his pieces. A few mosaic ceiling fragments that had been taken from the building mysteriously appeared in the spring of 2006 at Sotheby's, a high-end, international art auction. One piece was 41 inches by 24 inches

OPPOSITE, TOP
A photo of the Farwell Building taken on May 29, 2017, shows the building as renovations are underway at 1249 Griswold Street in Capitol Park.

OPPOSITE, BOTTOM
A fresh coat of paint and an added web address are visible in a photo of the Farwell Building taken October 26, 2017, at 1249 Griswold Street in Capitol Park.

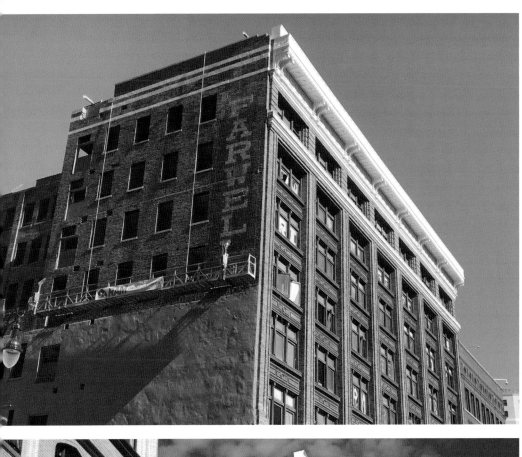

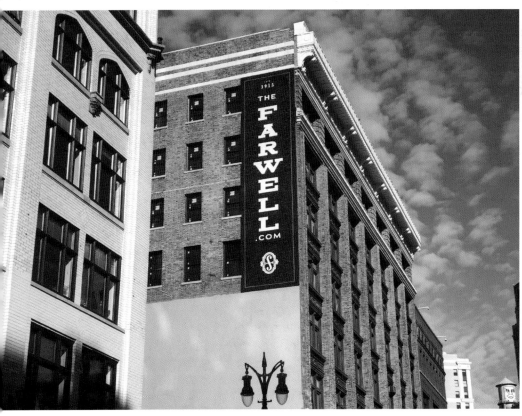

SELF STORAGE

Your Personal VAULT
SELF-STORAGE CENTERS

yourpersonalvault.com (313) 496-1296

with an estimated selling price of $6,000 to $8,000; the other was 27.5 by 15.5 inches at about $3,000 to $5,000, the *Detroit News* reported. The items were removed after Sotheby's received a complaint regarding rightful ownership. Historic preservationists had told the *News* that the pieces "were likely stolen from the building decades ago."

Before the Farwell was cleaned up, it was used in the filming of *Transformers: The Last Knight* (2017), and in June 2016, passersby could see crews with a cherry picker pointing spotlights through the windows, which remained marked with colorful graffiti. Through the next year, extensive renovations were made to bring eighty-two residential apartments—along with office space, retail areas and a rooftop deck—to the long-dormant building, according to *DBusiness*, a Detroit business journal.

Substantial renovations were planned for the lobby, "given scalpers have removed the original Tiffany ceiling fixtures along with portions of the glass tile in the dome ceiling. Still, many other original building materials remain, including iron and wood railing, marble floor, wall, and ceiling treatments, along with terrazzo floors on the upper levels," according to *DBusiness*.

By the time you read this, people may already be living there.

WEST SIDE BARS AND AVENUES

ABANDONED, DECAYING BUILDINGS—several covered in boards and graffiti—pock Warren Avenue on Detroit's west side, near the city's border with Dearborn. Before the city in 2016 installed sixty-five thousand LED streetlights, neighborhoods like this would sometimes be darkened for blocks with few or no working streetlamps. "I didn't have no streetlights for almost two years," said Brooksey James Irvine Jr., joking that he should have gotten a break on his electric bill for helping provide a little illumination. "I was the shining light for the night."

Brooksey's Exclusive Lounge, which he opened in 2001, still acts as a beacon. It's the only bar or restaurant for about ten neighborhood blocks of Warren between the border and Livernois Avenue. The nearest operating businesses are auto repair and tire shops. I arrived at Brooksey's on a Wednesday in December 2017, finding a warm, inviting, lively scene with all the barstools occupied and a few games of pool underway. A server walked around with samples of steak bites. And as the band started setting up near the sprung wooden dance floor, Irvine told me why this place exists.

ABOVE Brooksey's Exclusive Social Club offers a full bar, restaurant and live music on 7625 West Warren Avenue.

Growing up as the youngest of six children, he'd always admired his father, a musician who performed jazz, contemporary and more across the city, including at Belle Isle. "He used light up the neighborhood," said Irvine, fifty-four. "He'd come home from work in the summertime, have the door open. He'd be playing the trumpet and the piano at the same time."

Since he was young, Irvine recalled telling his father that one day he'd open a jazz café in his honor. "He had opportunities to go other places with other groups—The Dramatics, at one point in time," Irvine said. "But he gave it up because of us, you know. He didn't want to leave his kids."

Irvine went on to work in assembly at Chrysler's Jefferson North plant on Detroit's east side. In about 2000, when Irvine was in his late thirties, he still wanted to start a lounge. "I always held on to

that," he said. "So when he got older and sickly, I just felt like I wanted to give him something back before he passed—you know what I'm saying—to let him know that I appreciate him being around."

Irvine acquired the dilapidated building in April 2000 at West Warren Avenue and Central Avenue. He set to work improving it. "I was in here, working like crazy. I just felt like it could give him some life," Irvine said. "I know it sounds crazy, but I felt like that."

He brought in an artist who created the sign, "Brooksey's Exclusive Social Club," with a bust of his mustachioed father in a suit. But Brooksey James Irvine Sr. never got to see it. He died in July 2000. "When he was sick, he was a little incoherent, maybe—he might have heard me. I don't know. I told him about it," he said. "I wanted to surprise him."

After his father died, Irvine decided he'd just finish it up and then sell it. Brooksey's opened on Mother's Day 2001, and "before I knew it, I was just operating," he said. The customers kept coming. At one point, it was open seven days a week. He added the restaurant to the business. He was considering buying other properties along the block, but the Great Recession got in the way. "What I would like to see is more neighborhood-friendly businesses," he said. For now,

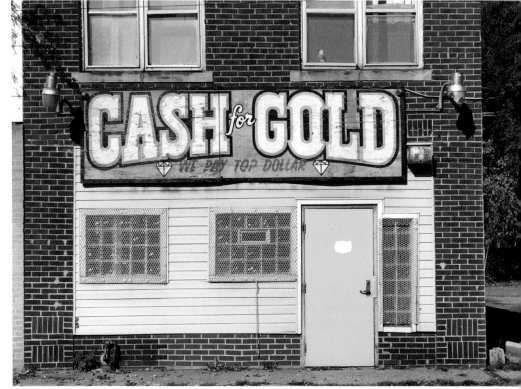

he's just focused on upkeep. The bar also helps serve the community. The night I visited, Irvine and his former classmates from the nearby, since-demolished Chadsey High School had given money and gift certificates to a family going through rough times whom they "adopted" for the holidays.

Before Irvine bought the building for Brooksey's, he said it may have been used for storage. As recently as the 1980s, it was the Venice Café. On the building's west-facing brick wall, the original "Venice Café; Dancing" sign remains intact, along with a heavily faded Pepsi advertisement. The Brooksey's sign is on the east-facing brick wall.

Over the front façade of the two-story building is a small sign in concrete, indicating it was constructed in 1925. Venice Café, open from 1941 to 1985, was previously owned by Frank J. Kapanowski, a boxer. This is from an obituary published on February 20, 1998, in the *Detroit Free Press* for Kapanowski, who died at eighty-six: "'He had quite a few fights professionally from about 1930–39,' his son Joseph said. Kapanowski was known for his left hook and right cross. He was a onetime state middle-weight champion, and boxed and coached while in the Army during World War II. He was wounded in the Battle of the Bulge and received a Purple Heart."

Much of what you would have seen walking into the Venice Café, you can still see on the interior of Brooksey's. The bar, including an etched image depicting a waterway in Venice, Italy, above the bottles, is intact except for the coolers. Lights along the ceiling, formerly blue and red, now shine green and yellow. The tiled bathroom is original, except for an added hand dryer. And of course, there's the dance floor, which gets regular use when Brooksey's is open Wednesdays to Sundays. Irvine said he hosts a wide range of musical acts, from country to jazz and rhythm and blues. He said his presence likely saved the building from demolition, and he hopes that at some point, the properties nearby will get some attention. "I feel like this is a doorway to the city," Irvine said.

OPPOSITE, TOP A ghost sign for Venice Café, along with a deeply faded Pepsi advertisement, is visible on the side of Brooksey's Exclusive Social Club on 7625 West Warren Avenue.

OPPOSITE, BOTTOM A "Cash for Gold" sign is seen on a building along Fenkell Street east of Trinity Street.

WARREN AVENUE:
A DETROIT CROSS-SECTION

You can get a fairly good idea of Detroit's present condition by taking a fifteen-mile drive across the city on Warren Avenue. Because it's one-way in some areas, it's best to start on the east side, at Warren and Mack Avenue.

You'll pass residential streets, including East English Village, known as one of the city's rising neighborhoods, with well-kept bungalows and Tudor- and Cape Cod–style houses. You'll drive by burnt-out buildings near others occupied for years by locally owned small businesses, such as barbershops, cleaners and pet supply stores. There's a dizzying mix of hand-painted signs spanning decades of opulence and neglect, along with ball fields, car repair shops, empty lots thick with grass where buildings once stood, churches, the city's celebrated Coney Island diners, a charred-out car wash surrounded by concrete crumbs and more.

You'll pass near the active Fiat Chrysler Mack Engine Plant and the rubble of deteriorating industrial blight, with acres of rotting wood and jagged concrete. Near East Grand Boulevard, the water tower of the massive, deeply decayed Packard Automotive Plant appears above the trees to the right. Closer to Warren, there are buildings actively housing the Faygo warehouse, LaGrasso Brothers Produce Company and Avalon Bakehouse. Next is Poletown East, a neighborhood populated by Polish immigrants in the late 1800s. Its light patchwork of still-standing homes is quiet and scattered with buildings turned prairies before you hit another industrial area and cross Interstate 75 into Midtown. Here is the city's urban core, where most of the fresh development is happening. The roads are smoother. You pass museums and Wayne State University.

Continue over the John C. Lodge Freeway—onward to Detroit's west side—and you're in Woodbridge, a historic neighborhood with tall Victorian homes, many of them well preserved. In 2016, skateboarding superstar Tony Hawk bought one of the red brick homes here, built in about 1900. It's a neighborhood with well-kept yards, flower pots on the porches and newer cars parked along the street. A few blocks later, you cross Grand River Avenue, and the burnt-out, abandoned buildings pop back into the scenery. Those tracts of grassy land once occupied by structures are back. This continues for a few miles, interspersed with a used car lot here and a party store there. You'll see Brooksey's, then you start seeing signs in Arabic. This is northeast Dearborn. A few miles later, you're back in Detroit, the Warrendale neighborhood. Its commercial activity isn't a lot different from where we started, with rows of low-rise, locally owned small businesses—some pretty run-down, others flourishing.

STORAGE COMPANY TURNED ART SPACE

This building, a little south of West Warren Avenue on 4731 Grand River Avenue, is easy to spot by the word "LOVE" spelled using the silhouettes of four giant hands across its street-facing wall.

Atop the west-facing side of the four-story building, the ghost sign for Leonard Storage Company is visible. Constructed in 1908, the building was used for fireproof business storage, according to the 4731 Gallery and Studios website. It later served as a sales center and warehouse for a furniture company.

"During the 1960s and 1970s the building was used by a motorcycle gang for gatherings and parties. It's rumored that club initiations and hazing were done in the basement, now haunted, according to a psychic that came through the building several years ago," according to the gallery website.

It was purchased in 2000 by Ric Geyer for workshops for himself and local artist Chris Turner. In the ensuing years, it was developed into 4731 Gallery and Studios with art spaces. *Crain's Detroit Business* reported in 2010 that space was being leased to artists at an especially affordable rate of one dollar per square foot. The structure was named Best Arts Building of 2004 by the *Detroit Free Press* and received a Cool Cities Award from the State of Michigan.

Baltimore artist Michael Owen painted the *LOVE* mural—the one with the silhouettes—in April 2014. He'd previously painted twenty of the pieces in Baltimore, and this was his first time extending the Baltimore Love Project to another state. While he was in Detroit, his rental car was stolen from the 5000 block of Grand Boulevard. But just as he was finishing the mural's letter *E*, he received word that the car had been recovered. Owen continued taking his project to other locations. In October 2016, he painted the same mural on the Einstein Bagels location across the street from Pulse Orlando, with forty-nine orange blossom flowers representing the people who died in the June 12, 2016 mass shooting at the nightclub, Kate Santich reported for the *Orlando Sentinel*. That mural was done using Owen's money with help from online donations. While he worked, people stopped by to thank him and give him snacks, and he said it was the only piece he'd done that received only positive responses. "People can look at the mural and put their own story in," Owen told Santich. "It's not limited to people who have a certain color hand or sexuality or religious affiliation. It's just people."

OPPOSITE A ghost sign for Leonard Detroit Storage Company is visible on 4731 Grand River Avenue, now home to a number of art studios.

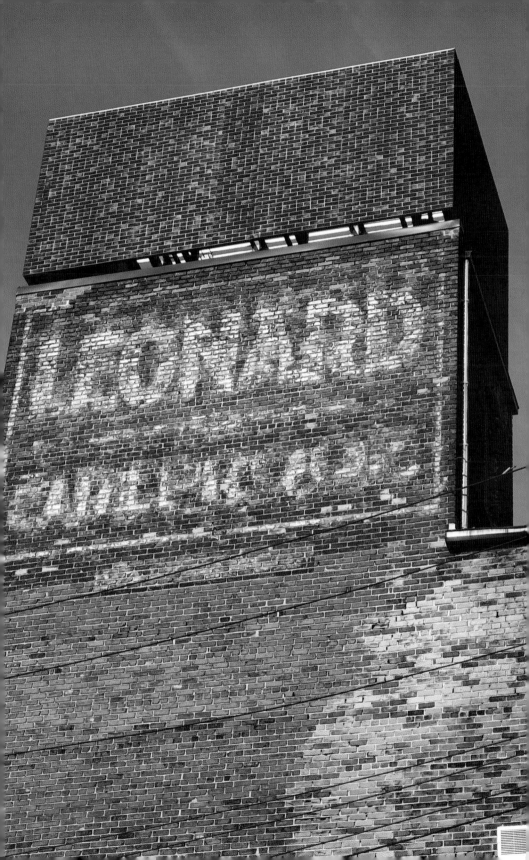

MOHAWK ROCK AND RYE

These days, the words "Rock and Rye" most often mean a Faygo soft drink. But the name's history is steeped in illicit booze. "One of the most unique Faygo flavors, still popular today, is Rock and Rye, reportedly named for a Prohibition-era drink made of rye whiskey and a cube, or 'rock,' of sugar," according to *The Vernor's Story: From Gnomes to Now* by Lawrence L. Rouch.

The Detroit-based Mohawk Liqueur Corporation, founded in 1933 (the year Prohibition was repealed), took the illicit drink's flavors and—as a newspaper advertisement in 1936 describes—made its own version, at $1.60 per quart, "prepared with orange, lemon and pineapple."

A ghost sign on East Warren Avenue and Barham Street reading "Mohawk Rock and Rye: World's Finest!" appeared recently on the side of a building that operates as a barbershop. As recently as September 2013, this sign had been covered by a vacant, red brick building. Like many others in this book, the sign retained its colors for decades, hidden away from people, sun and weather.

The Mohawk Liqueur Corporation was sold in 1966 to 21 Brands, which became a subsidiary of Foremost-McKesson in 1970, according to the *Las Vegas Review Journal*. In a June 2007 news release from Heaven Hill Distilleries, it announced that it had acquired the Mohawk product portfolio from Boisset America.

ABOVE Mohawk Rock and Rye is advertised on a ghost sign recently exposed by an adjacent building's demolition on East Warren Avenue east of Barham Street.

HOBBY BAR, SUMMER 1967

Detroit's July 1967 unrest, also known as the riot, uprising, rebellion or civil disturbance, lasted five days and left forty-three people dead.

The underground "blind pig" bar where it all started—with a nighttime police raid at Twelfth Street and Clairmount Avenue on Detroit's west side—is gone. A Michigan Registered Historic Site marker was unveiled at a park, in the summer of 2017, on the quiet neighborhood intersection now called Rosa Parks Boulevard and Clairmount.

Less than two miles northwest, you can still see the vacant, graffitied Hobby Bar building, the rusted edges of its metal sign with most of the lightbulbs missing. Hobby Bar opened on Linwood Street in 1952 as a piano bar, with jazz bands starting in 1960, according to *Before Motown: A History of Jazz in Detroit, 1920–60*, by Lars Bjorn and Jim Gallert. On July 24, 1967, the second day of the city's historic disturbance, it's where police ran after and shot a suspected looter. "Most of his last day alive, Richard Sims, thirty-five, of 2475 Buena Vista, had stayed home, passing time watching TV on the front porch," the *Detroit Free Press* reported on September 3, 1967.

The Chrysler employee had told his wife at about 8:30 p.m. that he'd be walking the half block to the Hobby Bar at the corner of Buena Vista and Linwood. A short time later, a woman who lived nearby reported seeing him with a hammer "trying to jimmy the side door" of the bar with another black man nearby, according to the report. Police driving north on Linwood saw them and chased the men on foot. The other man ran in a different direction, and police chased Sims, who ran down an alley and then up a driveway to the woman's house, trying to enter a side door. Police reported telling him to stop multiple times.

"Sims was shot as he struggled with the side door. He fell to the driveway, mortally wounded," the *Detroit Free Press* reported. "It seems now that Sims could easily have been apprehended. The side door was locked and officers appear to have been closing in from both front and back."

It added that neither Sims nor the officers knew the door was locked, and the officers may not have known their colleagues were closing in from the other side. "His shooting was witnessed by Mrs. Sims, although she couldn't see who the officers were taking under fire," according to the report. She asked a neighbor, who replied, "They just killed your husband between those two houses."

In the same article, the newspaper reported that at least fourteen of the forty-three who died were suspected looters. "The legal basis for shooting a looter is found in state law, which permits officers to fire at fleeing felons after an order to halt is disregarded. Technically, most of those who were killed clearly fall in

that category, though one is still left with a feeling that the thief who takes $5 worth of goods from a grocery store shelf and runs ought not to be required to pay with his life," according to the newspaper.

In 2017, the fiftieth anniversary of the riot was marked through tours, museum exhibits and in-depth media coverage, including reflections from people involved. "The insurrection was the culmination of decades of institutional racism and entrenched segregation. For much of the twentieth century, the city of Detroit was a booming manufacturing center, attracting workers—both black and white—from southern states. This diversity aggravated civil strife, and the Race Riot of 1943 highlighted the racial fault lines that crisscrossed the city," according to the Detroit Historical Society.

Industrial jobs left the city, and auto companies closed. Black Bottom and Paradise Valley, the city's two

ABOVE The sign remains intact on the former location for the Hobby Bar on Linwood Street north of Buena Vista Street.

OPPOSITE, TOP The
sign remains intact from
a former H.J. Heinz
Company (the Pittsburgh-
based maker of ketchup
and other foods) location
on 6030 Joy Road.

OPPOSITE, BOTTOM
A ghost sign for the
former Wrigley's Super
Markets is visible from
Schaefer Highway south
of McNichols Road.

main black neighborhoods, were demolished, and
white people departed on the new highways for new
housing in the suburbs. "Adding to the tensions was
the black community's fractious relationship with
the mostly white Detroit Police Department. Like
many forces across the country, the department was
known for heavy-handed tactics and antagonistic
arrest practices, particularly toward black citizens,"
according to the historical society.

The *Detroit Free Press* article described the
response after the blind-pig bar raid on a hot
summer night, when a brick through the back
window of a patrol car set off the disturbance.
"Thirty-six hours after the riot began, something
more than 3,000 armed men were assigned or had
access to a single twenty- by twenty-block area on
the near West Side, a concentration of firepower
paralleled only by a major military invasion force,"
the newspaper reported. U.S. Army paratroopers
were stationed on the east side, and city and state
police were joined by National Guardsmen in "scout
cars, paddy wagons, expressway cruisers, jeeps,
trucks, personnel carriers and tanks."

The paper reported that most of the victims
"should not have died....Among them are the most
innocent, a four-year-old girl killed by a wanton
bullet, and the most guilty, a drunken sniper who
died trying to take another's life."

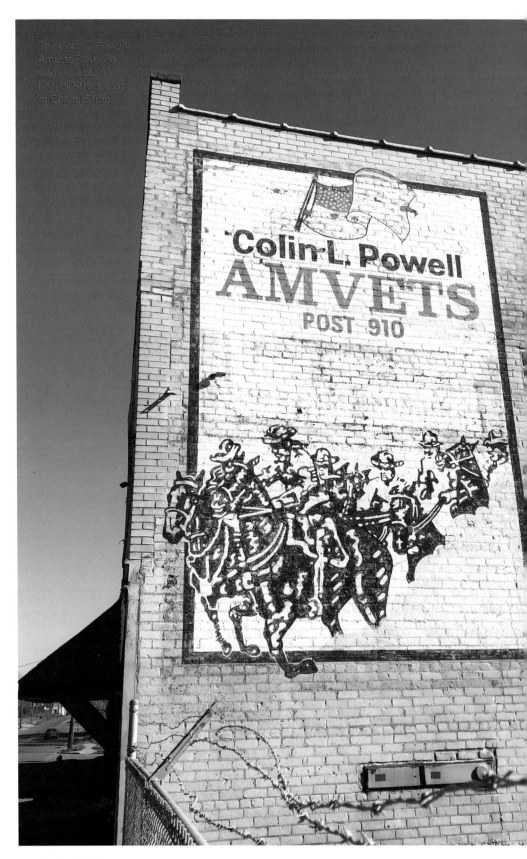

DOGGED IN DETROIT

ON A FADING STOREFRONT in a worn-out shopping district along Michigan Avenue, there's a man punching a tractor-trailer in its grill on a yellow sign that reads "Karate." That man is Delford Fort, the Yellow Tigers Karate School's founder. People said he probably could have stopped a truck.

"Delford was tremendous," said Randy Hargraves, fifty-five, a U.S. Army veteran who's helping keep the school running. He said that Fort, who stood about six feet, four inches, was "one of the most intelligent—kindest, gentlest men I met in my entire life. I had a great affection for him."

Hargraves said the sign with the cartoon of Fort is "kind of a comic character, is how he portrayed himself. But if there was anyone who could do something that was humanly impossible, then it was Delford."

Fort, after years of strokes, died in 2015 at age fifty-four. "After three strokes, he would still sit and curl a one-hundred-pound dumbbell. He just did it, continuously, like the weight wasn't there," Hargraves said.

Fort was only six years old in the summer of 1967. "He was born out of that riot, or the rebellion, whatever term you would use for '67," Hargraves said. Fort's mother got him involved in martial arts. "His mother wanted something to keep him off the streets and to stress discipline. In those days, everyone was learning from soldiers returning from Vietnam. They taught Korean Karate (now

ABOVE The sign for the former location of Yellow Tigers Karate School is seen at 4859 Michigan Avenue. The school has since moved to 3364 Michigan Avenue.

known as Tae-Kwon-Do)," according to the Yellow Tigers website.

Since childhood, Fort shared what he learned with other kids, helping them practice self-defense. He later became a police officer and founded the karate school. Hargraves said it serves a culturally diverse number of students from the surrounding area. "All of our children are at-risk, just by the nature of the neighborhoods they live in," he said. "I went to teach a class of seven-, eight-, nine-year olds; they say, 'Sensei, I hear gunshots outside, and the next morning, I come out to see blood on the ground. What am I supposed to do if there's a bad guy?'... Detroit's turning around, but our kids still live in some tough neighborhoods. I'm surprised at the number of kids who have friends who have died."

The average class is about twelve to eighteen kids, plus a few adults. The school also has partnered with community groups and neighborhood programs.

Hargraves said that for most of the students, "it's a hardship to attend tournaments and some (other) things commonplace for kids in the suburbs."

But Yellow Tigers has made sure it's able to participate, and the club has several champions. Kids are taught how to take a hit and survive, with violence as a last resort. Similar to Bruce Lee, he said Fort designed his own karate system, based off a hard-karate form that includes some grappling and wrist locks. "Our kids don't get style points at karate circuits," Hargraves said. "I spent a class here and there teaching common sense and how to run away from somebody with a gun. That's not traditional martial arts. That's street survival."

Beyond martial arts, the school acts as a community center. If a student has a friend who can't afford a quinceañera, the school serves as a venue. There are Saturday movie matinees and trips to the beach along the Detroit River. Many of the children have never left the neighborhood, so there are sometimes trips to downtown Detroit. Most of the students come from families who are "very challenged, financially," but no student who's unable to pay for the school is turned away, Hargraves said. "We've got a couple kids who've left the school, wounded by gunfire, [and also] a couple kids who were in school playing in gangs but are now in college," Hargraves said.

Fort's family remains actively involved, including his stepson, Caleb Moss, twenty-six, who graduated from the University of Michigan and now works as a graphic designer for the City of Detroit. Moss said he started instructing at the school when he was fifteen. After a typical day's work, he'll head to Yellow Tigers and help little kids learn how to stand up for themselves. "When you're away from the school, you realize how much giving back to others can actually help you," Moss said. Two years after losing his stepfather, he said he continued to hear from people reaching out to comfort the family, something he said "amounts to his character."

The students have ranged in age from three to sixty-six. "Families join," Moss said. "It might start off with kids, but it's definitely a family activity."

Yellow Tigers has had several locations over the years, including at a Baptist church at one point. And it's since moved from the location with the Fort cartoon, which was rented in a worn, mostly quiet shopping district on Thirty-Second Street and Michigan Avenue. Since about Thanksgiving 2016, the school has had its own building at Twenty-Third Street and Michigan Avenue, a few blocks west of Corktown.

Hargraves, of Taylor, also works for the city, as a supervisor of new construction and renovation work for Detroit's Building, Safety, Engineering and Environmental Department. He's used his own money to pay the karate school's bills for several years and calls himself the "custodian of Grand Master Fort's organization."

He'd met Fort in about 2009 after stopping in to ask if he could work out. A deep friendship bloomed, and Fort became his mentor and trainer. Fort had a stroke in 2011, and Hargraves helped him run the school as Fort dealt with his medical issues. "One of the things he was concerned about was, 'I'm gonna be gone. There won't be anything left to remember me by,'" Hargraves said, adding that he gave his word that he'd keep the school open. "He left it to me. I run it with [Fort's] wife and stepsons."

Many students get to the school on foot. When it moved about a mile east, it lost about 60 percent of its students. But Hargraves said that by late 2017, they were starting to grow. "I pretty much dumped my retirement, and I've poured my life and family's assets, into keeping the school alive," he said, adding that Fort always wanted the school to own its own building. That is now a reality.

Fort's history as a police officer wasn't without struggles. A report in 1991 in the *Detroit News* showed that Fort was honored as a community hero, spending "nearly all his spare time" working with youths, such as Boy Scouts, and by teaching anti-rape techniques at a local school. He befriended an older woman who had fallen and injured herself, visiting her multiple times per week and helping her start to walk again. But in November 1999, the *Detroit Free Press* reported that he and another Detroit police officer were indicted on allegations of stealing nearly $30,000, jewelry and more than one pound of crack cocaine during two years of drug raids. Fort was convicted at jury trial and sentenced to twenty months in prison; he was released in February 2003, according to federal records.

Nonetheless, the Detroit Police Department honored Fort with an entry in the "Police Memorial" page of its 2015 annual report. Hargraves said Fort had shared a little with him about his time in prison. "The Delford I know—for years I knew him—there wasn't more of a gentleman that I ever met," he said. "There wasn't a kinder human being. I've loved maybe two or three people in my life. Delford pushed people to be better."

HYGRADE DELI

A highway interchange and a few blighted blocks separate this deli, west of downtown on Michigan Avenue, from trendy Corktown. Here, in a small diner known for its Reuben sandwich, is where Stuart Litt has spent more than forty years.

You can find him here every Monday through Saturday, for breakfast and lunch, running the business that he's owned through very bad times. When a nearby Cadillac plant closed, he lost customers. The building across the street went from housing a nut-and-bolt manufacturer to a chop shop before becoming vacant. People threw bricks through the windows, and nobody replaced them. "It was a typical eyesore," Litt said. "One that people would take pictures of."

Broken, missing or boarded-up windows are still easy to spot on haggard storefronts along the four blocks east of Hygrade Deli. Through the 1980s, the disappearance of nearby jobs affected businesses like his. "All the little mom and pop stores and this, that, the other thing were either closing up, or people were moving out, or people retired, and nobody took over businesses," Litt said. "We started a steady decline here at Hygrade."

He didn't take a vacation from 1989 to 2015. "I'm a bottom-line guy," Litt said. "I can't afford to close that Saturday in front of Memorial Day [or] Labor Day. I need the cash flow to pay the bills. We started to struggle for a long, long time."

Most of Hygrade Deli looks the same as when his father purchased it in 1972. It's a clean, well-kept diner with wood paneling on all the walls. A glass refrigeration case contains cans of cream soda, bread and plastic wrap–covered salads. There's a big meat slicer, which Litt still uses regularly to make sure the work is done right. There is no computer system—all the bills continue to be calculated by hand. And there's Litt: a tall, slim, balding Jewish man in his early sixties with a moustache and a frank, sharp and outgoing demeanor, wearing his clean white shirt and dark apron.

He persevered through the Great Recession. And by the early 2010s, he began to see an uptick in business, getting "really strong the last three years or so." He said that billionaire businessman Dan Gilbert's moving his Quicken Loans to downtown Detroit appears to have a substantial role in driving it. "It's just been a deluge of people coming down town, new homes, constructions and lofts," Litt said.

ABOVE The Hygrade Deli operates at 3640 Michigan Avenue.

That building across the street, the eyesore, today has shiny windows and a clean façade. It's the headquarters for L.S. Brinker, a construction management business with revenues between $70 million and $100 million, according to a January 2017 article in the *Detroit Free Press*.

The activity trickled across the highway interchange to Hygrade, essentially doubling the number of customers on Saturdays. But Litt still feels pain from the tough years, when he'd been forced at one point to max out his business credit card. "Things break down in the restaurant business," he said, adding that sacrifices were made to get the repairs done and keep the deli running.

"Me personally, I'm still not solvent....I took a huge hit financially. My personal credit card had to repair things at home. I may still have to work until I'm seventy to get out from under the situation that we dug here."

This was not the plan. Litt holds a business degree from Wayne State University in Detroit, earned taking night classes while helping his father, Bernie, run Hygrade Deli in the mid-1970s. "The plan was, I would get a degree and go with that somewhere, somehow, some way," Litt said. "And then, coincidentally enough, when I was graduating in December of 1977...my dad had a minor, mild heart attack—whatever you want to call it. And he could not work. Doctor's orders, obviously."

Before his father was able to return to full-time work, Litt said that "there was nobody to run the store in the meantime." So he took over, anticipating that he'd move on once his dad returned to work. But when he did, Litt stayed too.

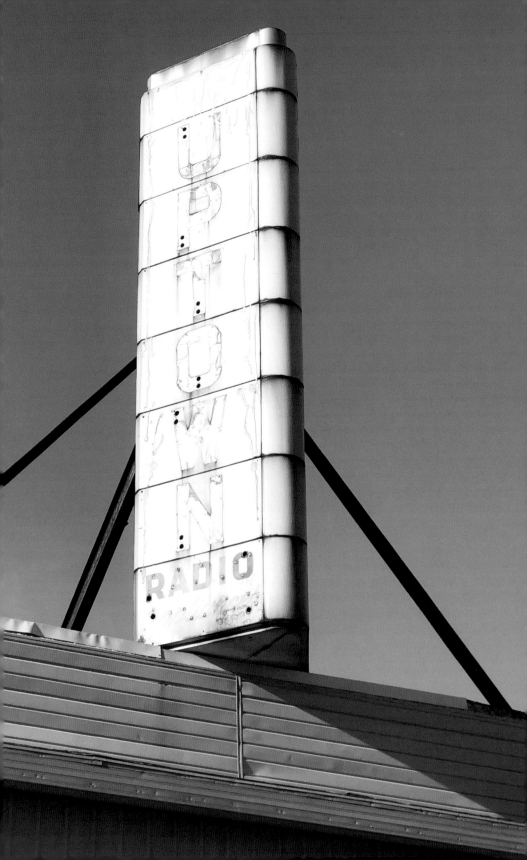

"The plan was I would then, OK, take my degree, go interview for jobs and leave the establishment," he said. "I never left."

Litt said that perhaps, subconsciously, he knew he couldn't leave his father. "Because there was nobody else to back him up, you know?" he said. "Maybe that played a part, in the back of my mind. It might have been laziness on my part and not saying, 'OK, you're back full time now. Let me go back into the interview process let me send my résumé out. See what happens.' I was probably very lazy about that, so I never left."

Through the down years, as businesses around him closed, Litt could have had other opportunities to move on. "A good question could be, 'OK, if things were that bad, why didn't I just look to sell the building and the property, take the money and go open up somewhere else?' Maybe I wasn't smart enough to do that," he said. "There would have to be a lot of my time and effort into doing that, and because I'm here twelve hours a day, trying to make sure this place goes—when do I have the time and effort to get into something like that?"

His staff consists of him, his wife and about five employees. The owner, who lives in Southfield and also has two grown sons, said he rarely even takes a half day away from work during business hours. "The aggravation level for me is an all-time high," Litt said. "I have a good crew of people, but there's a lot of aggravation with each individual, for whatever reason....A number of them just can't remember a goddamn thing. If I order a thing and it comes out another way, why? Why is it still not right?"

And the customers are "much more difficult" than they used to be. There are still "times it's fun here," he said. He's planning to give it about another four years before considering retirement. "I'll be a greeter at Sam's Club," Litt said. "Or I'll go cut corned beef for somebody else."

OPPOSITE The sign for Uptown Radio and Appliances, previously covered by a Family Dollar sign, is now exposed on Woodward Avenue south of Ferris Street in Highland Park.

LANDED IN HAMTRAMCK

When Pawel Rzedzian arrived in Detroit in 2005, he worried that he might have taken a wrong turn and ended up in the wrong country. "I'm coming in and thinking, 'Oh my god, where I am like civil war or something,'" said Rzedzian, who was born in Poland, remarking on the blight he observed. He added that when he saw the Kowalski Sausage Company sign on Holbrook Avenue in Hamtramck, he knew he was in the right place. "First impression, I wasn't happy with what I see." He had previously lived in New Jersey, where he got married. His wife's family was part of the Polish community in Hamtramck, where housing was much more affordable, so they moved.

The enclave, about two square miles near the center of Detroit on the east side, was first settled by Germans. It became a village in 1901 and was incorporated in 1922 as a city, according to the *Detroit Almanac*. As the automotive industry boomed, many Polish people moved to the city, and by the 1970s, Polish Catholics accounted for 90 percent of the population, according to a report in the *Washington Post*. Later, younger Polish American residents moved to the suburbs for bigger homes, and immigrants from countries such as Yemen and Bangladesh arrived. In 2015, with a population of twenty-two thousand, the city elected the first Muslim-majority city council in the United States, the newspaper reported. The community is a tight cluster of neighborhoods with corridors of diverse businesses, from Polish and Arab markets to an astonishing number of dive bars.

"Prices always cheap—$5,000, $15,000, $20,000 for house," Rzedzian said of the real estate he'd seen advertised online in the surrounding area before he arrived. "But then you don't see neighborhood. Houses burnt out, liquor store across the street."

He found work in the residential roofing business. It involves a lot of trash, and he had trouble relying on other companies to get trash-trailers to and from worksites. So he bought his own trailer to haul trash. When the one was getting full, sometimes he'd need another, so he bought a second. And a third. "Eventually, I have ten trailers," he said. "I figure, why not rent some?"

The entrepreneur, now thirty-eight, is two years into the trailer-hauling business on Conant Street near Victoria Avenue, in Detroit a few blocks north of Hamtramck. A wall of cinder blocks stands facing the street where a previous business had a door and several windows. Rzedzian had a local artist paint the "Dumpstar LLC" sign over the blocks, showing off his business with a bright, colorful painting of a bird that looks like the Warner Bros. Road Runner hauling a wooden cart loaded with junk down a desert road. "You know, like a roadrunner, it's pretty quick: quick service," he said, adding that the green triangle indicates

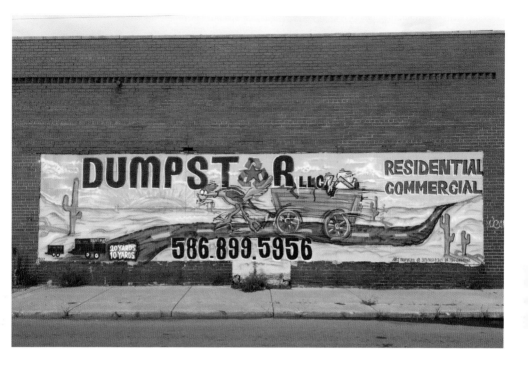

the business's efforts to be eco-friendly. "We try and recycle."

The trash trailers are for commercial as well as residential use, at a time when blight-clearing efforts are actively hauling out debris across the city. He has a family with two kids, along with a more optimistic view of the area. "We haul the trash to help rebuild the city," Rzedzian said. "I move here, I saw the city like trash. And then I start living in it—I saw positive things."

ABOVE The Dumpstar LLC sign is visible on Conant Street south of Victoria Street just north of Hamtramck.

BILL'S RECREATION

It's a muggy summer afternoon, and the sun's draining the sweat into my dress shirt as I watch a sign painter finish a piece in Eastern Market. Unfastening the second button on my now-sticky shirt, I step into my Jeep, crank on the air conditioner and dive into the city streets at rush hour. Each day, I take a different route from downtown, northward to my neighborhood along 8 Mile Road near Woodward Avenue. I search for ghost signs and good stories.

Today, I'll take Rosa Parks Boulevard, also known as Twelfth Street, over which the violent unrest of 1967 commenced exactly fifty years earlier. I'm westbound on Martin Luther King Jr. Boulevard at Third Street when I start to pass Bill's Recreation. The mural facing the street shows a man in a Detroit Tigers hat shooting pool. It's bright, a little amateurish and stands out on a pretty dreary part of the Cass Corridor. I'd been at this intersection before, reporting on a man who stabbed two EMTs in the face. Both survived. They'd arrived after midnight at the location near the Neighborhood Services Organization, which helps homeless people, in response to a call for an ankle injury. This memory comes to me as I decide to parallel-park in a no-parking zone, quickly hop out and photograph Bill's Recreation. I'm dehydrated, and my wife is texting me to come home for dinner.

But as I'm taking shots of the wall, the owner comes around the corner and asks what I'm doing. We start chatting. A few minutes later, I'm sitting next to longtime customer Edward Moore, a seventy-eight-year-old Detroiter who first walked in the door of this pool hall forty

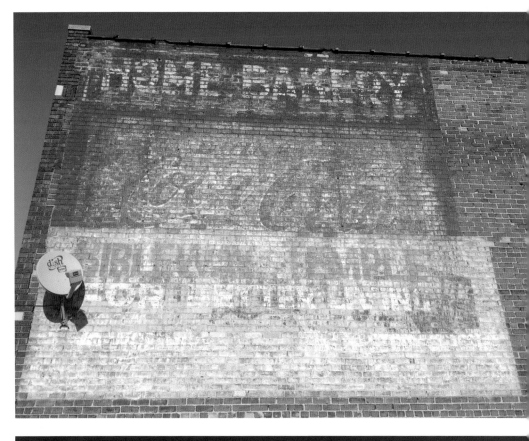

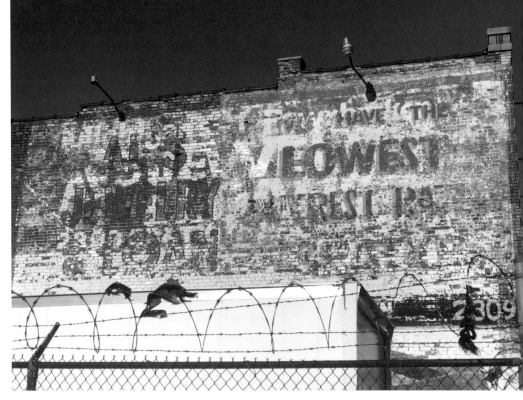

years earlier. "I was the youngest," Moore said. "Now I'm the second to the oldest."

This is the last pool hall left in Detroit, John Carlisle reported in 2016 for the *Detroit Free Press*. Here's how he explained the area: "Bill's is located in the shrinking wedge of what's left of the Cass Corridor, which for decades was Detroit's skid row. The gentrification of what's now called Midtown is edging closer from the north in the form of trendy new restaurants and rehabbed old buildings. The revitalization of downtown encroaches from the south."

Bill's Recreation dates back as far as the 1960s. There's no bar, no alcohol. The few old-timers inside sit on old barstools around green-felt pool tables inside plain, white walls. On a back wall, funeral notices for former customers are posted. Moore is a regular here, five days a week. It's a calm scene, and he gets his exercise walking around pool tables. "There's very few places you can go in urban areas that don't have guns and drugs," Moore said. "I can catnap here."

He previously had a union job at Anaconda American Brass before it moved out of the city, he said. Moore stayed here and bought real estate, including buildings in Midtown and New Center, now thriving areas surrounded by neighborhoods in deep poverty. Reflecting on Detroit's decades-long decline, he said that "despair and anger and no hope" drive poverty—people without jobs, and with poor education, lost hope. "Yes, the crime is bad because people are unemployed," he said, adding that even for people in nicer suburbs, "Let those people go without jobs, and it's going to be a rebellion."

Moore also said that in his case, he got a little too focused on work. He was married fifty-three years, and he regrets having put more of his focus on his work than his wife. He was eighteen when they started dating, and she was sixteen and got pregnant. They had five daughters and a son together. "I'd rather have had my family, rather than all the luxury that I've had," he said, sitting in the quiet pool hall.

As for the changes happening in Detroit, he said he's optimistic. "Each year, it's getting better," Moore said. "The people that's coming back to our city are people that are working."

OPPOSITE, TOP A sign advertising Home Bakery, Coca-Cola and Bibleway Temple is seen on Joy Road east of Genessee Street.

OPPOSITE, BOTTOM Al's Jewelry and Loan is advertised on a building on Gratiot Avenue south of Chene Street.

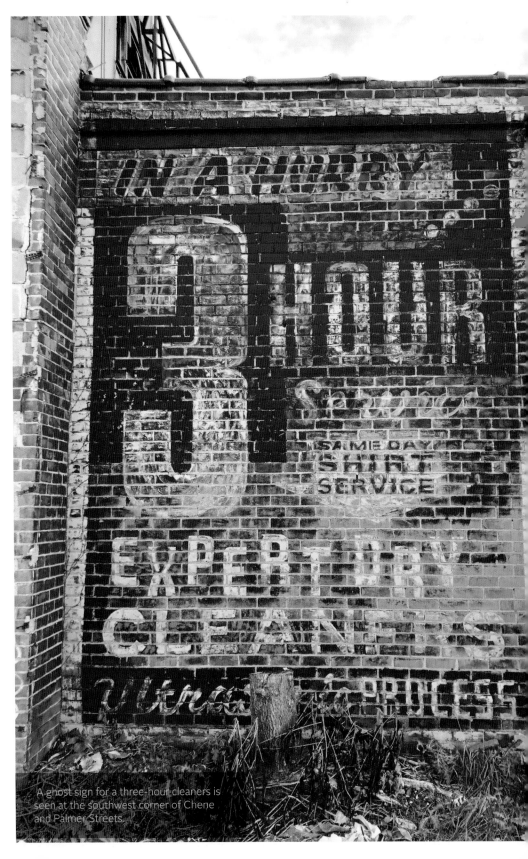

A ghost sign for a three-hour cleaners is seen at the southwest corner of Chene and Palmer Streets.

EAST SIDE BOMBINGS, BOWLERS, FARMERS

BOMBS TARGETING eighty garment-cleaning businesses rocked Detroit in the mid-1920s. As the *Detroit Free Press* reported in 1925, officials prepared a counteroffensive to a "band of wreckers who for nine months past have gone about Detroit throwing stench bombs into establishments of dry cleaners and hand laundries in the course of a guerilla 'trade war.'"

Damage at the time was estimated at $100,000 (about $1.4 million in 2017 dollars), and the attackers escalated from stench bombs to nitroglycerin explosives. But even the stink bombs caused massive damage, as people were unable to enter the buildings for up to three weeks after an attack. All the clothes inside were ruined, and business owners had to reimburse their customers. The victim store owners had refused to give in to a trade association's illegal price-fixing. The Purple Gang, Detroit's most notorious organized criminals in the 1920s to 1930s, oversaw the operation, according to the Detroit Historical Society.

The conditions leading to the attacks involved competition so stiff that business owners couldn't turn profits. And tailors frequently walked on their cleaning bills by switching to different stores, further raising tensions. "Seeing an opportunity to bring organized crime to Detroit, Francis X. Martel of the Detroit Federation of Labor asked Chicagoan Ben Abrams to establish a cleaners' organization that could be used as a front for the Purple Gang. Abrams founded the Wholesale Cleaners and Dyers Association, which pledged to stabilize the market by controlling prices and prevent tailors from switching cleaning companies without cause," according to the historical society.

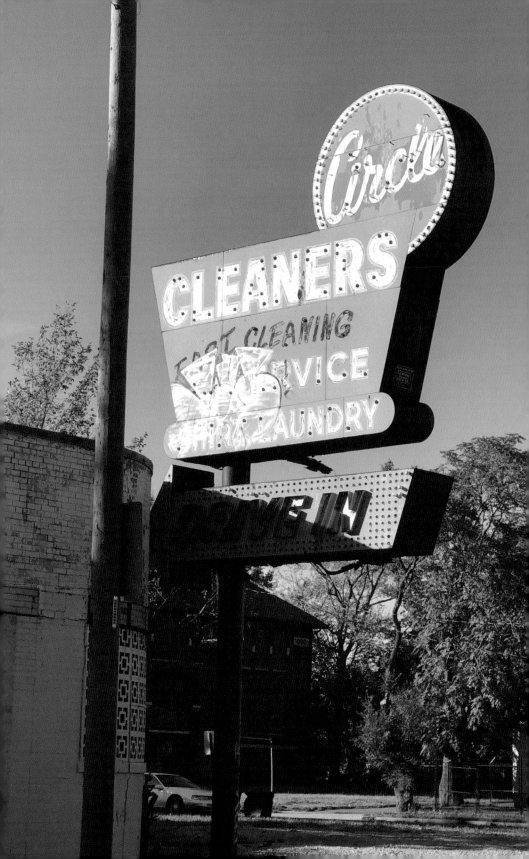

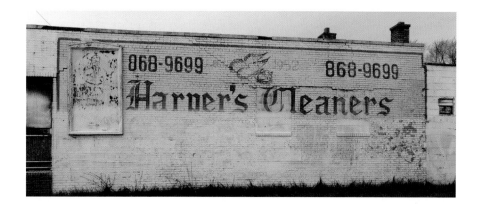

OPPOSITE
A ghost sign for
Circle Cleaners is
seen along Van Dyke
Street north
of Milton Street.

ABOVE A ghost
sign for Harper's
Cleaners is visible
on Davison Street at
Lumpkin Street.

The gang would leave partly burned dynamite sticks outside plant doors as a warning: pay membership dues or get bombed. "Two vocal opponents, Sam Sigman and Samuel Polakoff, were murdered," according to the historical society. Known as the "Cleaners and Dyers War," the conflict led to twelve gangsters being tried for extortion in 1928; everyone was acquitted, but the bombings ended.

The Purple Gang, composed of immigrants from the city's lower east side, also supplied whiskey to Chicago gangster Al Capone and controlled the city's underground gambling, liquor and drug trades. Its demise came in about 1931 after the "Collingwood Manor Massacre," when three members found to be working in their own interest were invited to a peace negotiation and shot. The gang had operated by intimidating witnesses from testifying, but a man who transported the men to the massacre gave in to police pressure to snitch. Several men involved with the shooting were convicted with life sentences for the massacre, helping to bring about the Purple Gang's end, according to the Detroit Historical Society.

Harper's Cleaners and Circle Cleaners, both pictured in this book, appear to have opened after the Cleaners and Dyers War subsided. Circle Cleaners operated about eighteen branch stores in the 1930s, and a sign for one location—which was open at least as far back as the 1960s—can be seen on 11525 Van Dyke. The Harper's Cleaners location on Davison Freeway, between Joseph Campau Avenue and Dequindre Street, was established in 1952 and continued to operate into at least the mid-1990s.

BOWLING CITY

Bowling used to be huge in Detroit. For decades, the city was widely known to be the world's bowling capital. Today, it is down to only a handful of bowling centers. In 2017, there were four: Garden Bowl (sixteen lanes) on 4120 Woodward Avenue, Renaissance Family Center (forty lanes) on 19600 Woodward, Punch Bowl Social Detroit (eight lanes) on 1331 Broadway Street and the Detroit Athletic Club (eight lanes) on 241 Madison Street. The closing of bowling alleys across the region matches a state and national trend of decline.

In 1941, Detroit had eighty-nine, according to *Historic Detroit*. Enthusiasm for bowling was so high in the mid-twentieth century that local newspapers had sections devoted to stories and scores. Employers—especially breweries, such as Stroh's Brewery Company—sponsored teams. But as Detroit lost its population, the city's bowling lanes started closing. Bowling centers take up a lot of space, and as they went out of business, many were repurposed.

"They were probably pretty well constructed, because of the vibration and pounding they had to take," Tom McKay, executive director of the Greater Detroit Bowling Association, told the *Detroit Free Press* in a 1994 article. "Rather than knock them down, they've been remodeled."

Chandler Lanes occupied a fifteen-thousand-square-foot building on Harper near Conner, overlooking Interstate 94, until it closed. It was turned into W.A. Genso Cartage Company, a trucking company. Across Metro Detroit by about the mid-1990s, closed bowling alleys were converted into a Barnes and Noble

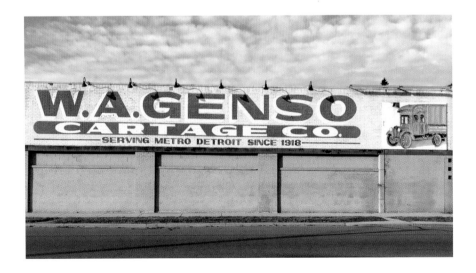

bookstore, a Home Depot store, a BMW dealership, a Red Lobster restaurant and a Habitat for Humanity warehouse and training center.

Despite the decrease in venues, the sport and leisure activity continues to draw participants in the suburbs. Detroit's metro area in 2015 had the most members (forty-five thousand) in the U.S. Bowling Congress of any metro area, the *Detroit Free Press* reported. If you're looking for an authentic Detroit bowling experience today, Garden Bowl in Midtown is one of the top five oldest bowling centers in the United States, according to the *Detroit Almanac*. It opened in 1913.

OPPOSITE A sign for W.A. Genso Cartage Company, at the location of a former bowling alley, is seen along Harper Avenue at Annsbury Street.

ABOVE A peeling sign for Elevator Technology is visible along St. Aubin Street south of Forest Avenue.

ARCADES IN DETROIT

Hot new characters Pac-Man and Donkey Kong hit Detroit in the early 1980s as a wave of coin-fed video arcades opened in neighborhoods across the city. But for many residents, their image wasn't one of childhood merriment. It was drugs, broken windows and sawed-off shotguns. It was bad kids, up to no good. "A lot of people thought this was going to be the second coming of rock-and-roll," Isaiah (Ike) McKinnon, former Detroit policeman, police chief and deputy mayor, told me for a story in the *Detroit Free Press*. "People thought it was going to turn the kids into hellions."

The spacey noises, flashing monitors and button-mashing kids in darkened settings made people uneasy. Neighbors called one area of Detroit "Hell's Half Mile" because of the crime neighbors were convinced a local arcade was inspiring. The *Detroit Free Press* reported in 1983 that Detroit had nearly one hundred arcades. The city passed tough restrictions targeting youths, and a short time later, the arrival of in-home gaming systems hastened the end of the golden age of video arcades.

More than thirty years later, the old, tall cabinets with their heavy, cathode-ray tube screens are ancestors of high-tech games you can play on your cellphone, electronic tablet, personal computer or home gaming console. But those coin-operated cabinets are seeing a new life as a trend toward vintage gaming sweeps across the United States. Many kids from the 1980s now have disposable income. Combine their nostalgia with what's known as the golden age of craft beer—in Michigan alone, the number of breweries more than doubled from 2011 to 2016—and you get an easy sell: two arcade bars opened in downtown Detroit in 2017, offering walls full of games from the '80s and '90s, along with craft beverages. The anti–video arcade laws of the 1980s don't apply to bars, so the entrepreneurs are in the clear.

OPPOSITE, TOP The severely faded sign for a snack shop and video arcade is visible in a neighborhood along Modern Street west of Arlington Street.

OPPOSITE, BOTTOM A sign for Detroit Pump is visible along John R. Street south of Brentwood Street.

VIBRATIONS BAR
AND GRILL

An artery through Detroit's east side, Gratiot Avenue is loaded with an array of signs old and new, from Faygo Beverages and Better Made Snack Foods to restaurants and abandoned tire shops. "It's a great corridor," said Alex Lindmeier, thirty-nine, who moved to Detroit in 2013.

He approached me while I was taking photos of a neighboring building to ask whether I knew anything about the one he'd recently purchased. Lindmeier is originally from California, and his wife is from Hong Kong, where they had lived for several years. But their jobs allowed them flexibility to move, and they found Detroit's prices to be

BELOW The faded sign remains intact at the former home of Vibrations Bar and Grill on Gratiot Avenue north of Whithorn Street.

OPPOSITE A variety of seafood is offered at the Asian Fisheries Fish Market on Gratiot Avenue north of Cedargrove Street.

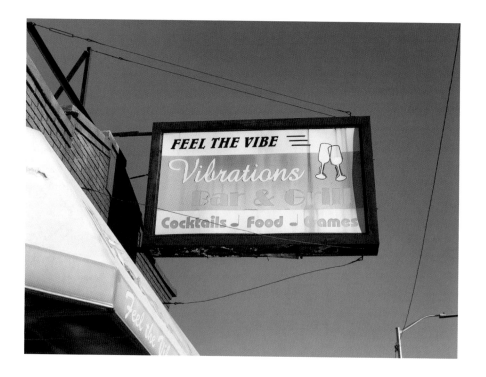

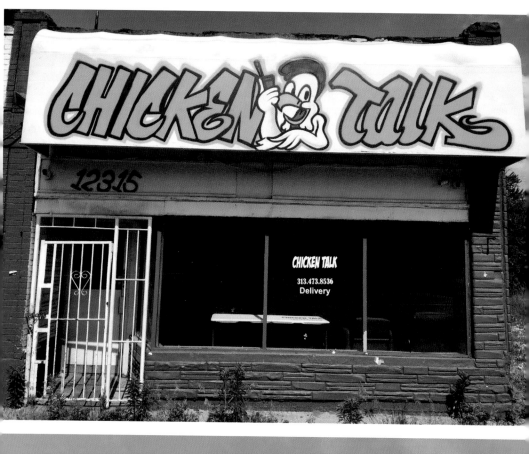

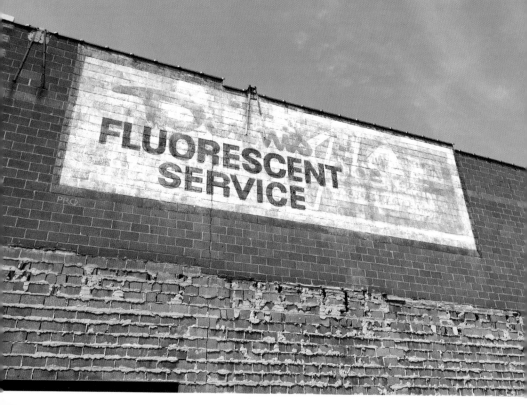

much more affordable than Hong Kong—one of the world's most expensive places to buy real estate. In September 2016, they purchased from Wayne County the vacant building on 12327 Gratiot Avenue that was previously Vibrations Bar and Grill. It cost $5,000.

"The inside's a mess," Lindmeier said. His first project was sealing the roughly 1,200-square-foot building, starting with the roof. Inside, he said there's still a "big, long bar where you can tell people just came in."

They aren't sure just what to do with the place, but they're considering a café. The renovation will give the building yet another identity after decades of changes dating to the 1920s. In 1929, it was described in a classified advertisement as a confectionery "doing good business," but the owner wanted to move to California and "will consider good used car as part down payment."

By the 1950s, it was Steetz Bar. And in the 1990s, it was "Al's Inn," a bar and building seating sixty-five on sale for $15,000 down—three times the value the building would later sell for, after years of neglect.

OPPOSITE, TOP
The since-removed sign for Chicken Talk was visible on June 10, 2017, on 12315 Gratiot Avenue.

OPPOSITE, BOTTOM A sign advertising Dennis Fluorescent Service is visible on 13141 Gratiot Avenue.

J. HERMAN FURNITURE

The heavily faded sign for J. Herman Furniture can be seen on a vacant building on an especially quiet Oakland Street corridor, at the North End, just across Interstate 75 from Hamtramck.

A 1934 newspaper advertisement shows "J. Herman" at 8837 Oakland Avenue as a Philco High-Fidelity Radio dealer. A Philco radio at the time came in a large wooden cabinet. Prices ranged from $20 to $600, which in 2017 dollars would be roughly $366 to $11,000. "With this new PHILCO you will hear the resonance of the deep bass, the radiance of the high treble. You will hear every instrument, every voice, every inflection of speech accurately and naturally," according to the advertisement.

A 1931 advertisement eagerly urged people to visit a furniture auction at this J. Herman Store. "This is one of the finest selections of new furniture ever sold at public auction, and must be sold to raise cash. Try to attend this sale and buy the best furniture at the price of inferior merchandise. Your attendance will be appreciated," according to the advertisement.

RIGHT A deeply faded ghost sign for J. Herman Furniture is seen on the north-facing side of a building at the southwest corner of Oakland Street and Holbrook Street.

HABERDASHERY TO FARMLAND

Small trees grow from debris behind the crumbling walls of a rectangular building on Detroit's east side, where formal suits were once tailored. Despite the cave-in and graffiti, a black sign with white, Art Deco–style lettering is clearly visible: "Rathnaw."

The former owner—decades before the property on the corner of Chene Street and East Forest Avenue was converted into a party store and, finally, abandoned—was Anthony J. Rathnaw, also known in the 1950s for his work as a Democratic politician.

Rathnaw was born in 1896 in Detroit to Kashubian immigrant parents from Poland, said his granddaughter, Carolyn Kinsler, who lives in the Ann Arbor area. He sold clothing for the store's owners before buying and renaming the business.

And the Rathnaw Clothing Company wasn't only a haberdashery. It also sold bowling apparel. A 1957 newspaper advertisement offered $1,500 in U.S. Savings Bonds to men who bowled a perfect game, and women who bowled a game of 275 or better, while wearing Rathnaw clothing in sanctioned competition.

Rathnaw owned the business for thirty-one years before turning it over to his eighteen employees near the time of his appointment in the 1950s as a Michigan Liquor Control commissioner. He made headlines with his push to loosen up liquor laws. Among his ideas were for bars in larger cities to be allowed to operate until 4:00 a.m. and to sell liquor on Sunday. His efforts to deregulate the industry caused Reverend E.C. Prettyman, an executive with the Michigan Temperance Foundation, to call for his resignation: "The chaos that would result from such changes certainly indicates that Mr. Rathnaw has no conception of the nature and importance of his position as a commissioner," the *Detroit Free Press* reported in 1954.

Prettyman also said he objected to Rathnaw accusing the state of "Gestapo practices" in the way it used license suspensions to discipline liquor law violators. However,

OPPOSITE, TOP The former home of Rathnaw, a haberdashery, is to be demolished as the property is used for Recovery Park, an urban farming effort.

OPPOSITE, BOTTOM The former home of Lip-Pan TV, VCR and Stereo Repair is boarded up and vacant on the northwest corner of East Warren Avenue and Chene Street.

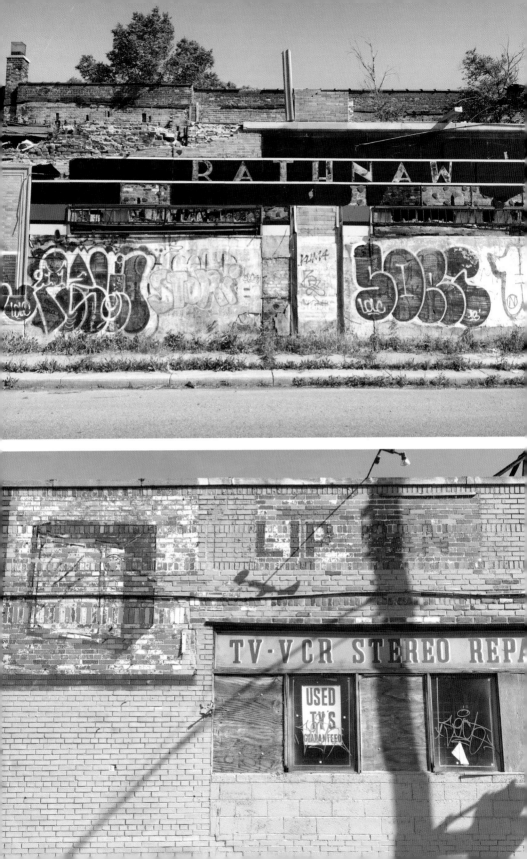

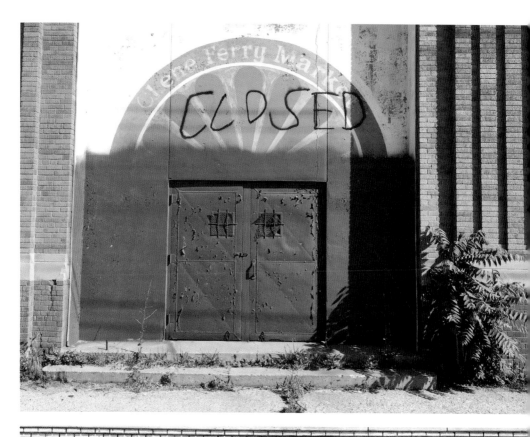

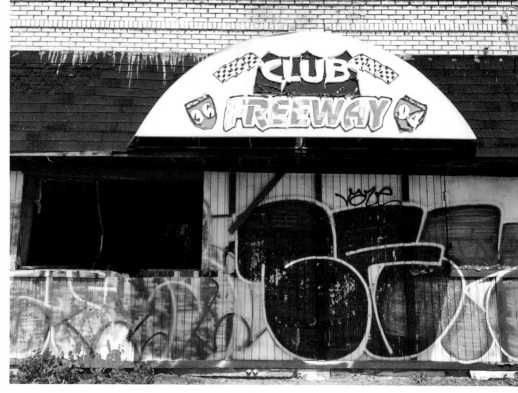

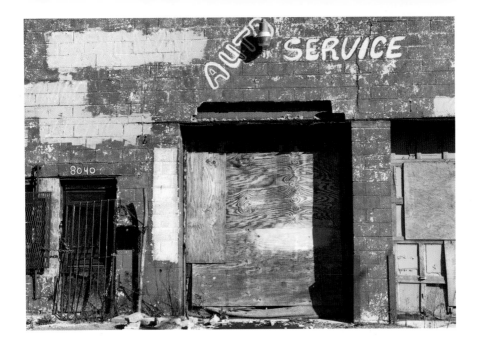

Rathnaw also urged for increased limits for fines and for an automatic revocation for license holders with four violations in a ten-year period. More than sixty years later, Michigan's bars sell liquor on Sundays, and while last call is 2:00 a.m., the legislature as recently as 2015 considered creating a 4:00 a.m. option.

"[Rathnaw] was quite active not only in politics, but he was really involved with the Polish community in that area of Detroit," Kinsler said, adding that he was especially involved with St. Albertus Roman Catholic Church. This was known as the first parish established in Detroit to serve a surge of Polish Catholic immigrants, according to the *Detroit Free Press.*

Kinsler said he continued to be involved with the store into his seventies. In about 1971, Rathnaw was there when robbers broke in, beat him up and stole merchandise. She said he wasn't seriously injured but was shaken up by the incident and sold the property.

Rathnaw died on November 4, 1976, at the age of seventy-nine, according to his obituary. Kinsler said it was only within the past several years that family members discovered the building still standing. "It's beautiful," she said of the building's façade, which is now in deep decay. It's slated for demolition in 2018.

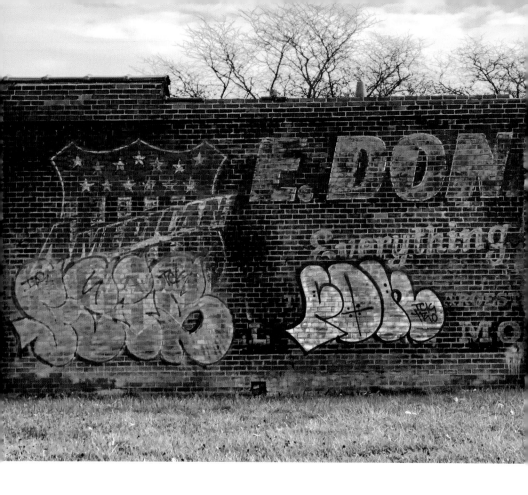

FARMS OF CHENE-FERRY MARKET

The Rathnaw building's remains are part of an area known as Poletown East, on Detroit's near east side. This neighborhood, even in a city of widespread blight, is especially quiet. But there's a pretty fascinating reason for it: twenty-two blocks, or about sixty acres, of the once-bustling area are hoped to be converted into urban farmland, creating jobs for "ex-offenders, recovering addicts and others with significant barriers to employment," according to a City of Detroit news release from October 2015. The nonprofit Recovery Park's farming operations sell fresh produce to many of Detroit's "finest restaurants," according to its website.

"We are in the process of building commercial farming facilities (high tunnels and greenhouses), and our available properties will be set aside for future development once it is environmentally safe and stabilized in the next three to five years," Recovery Park nonprofit manager Anna Kohn said in an e-mail confirming plans to clear the Rathnaw building site in 2018.

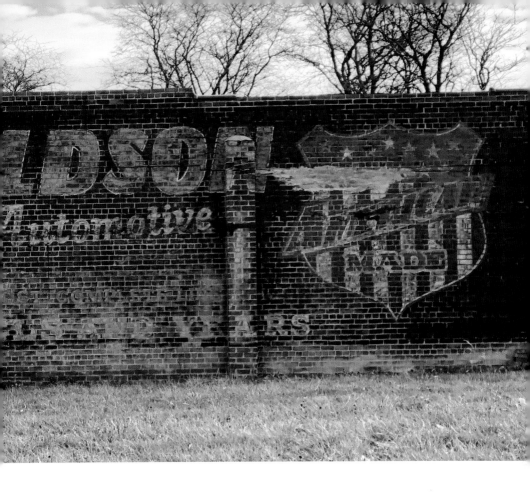

The neighborhood previously was populated with a growing Polish American population that began immigrating shortly after the American Civil War and continued "in huge numbers from 1890 to 1920," becoming Detroit's largest immigrant group, forming 20 percent of the city's population, according to the *Detroit Almanac*.

The largest remaining structure in the Recovery Park boundaries—from Interstate 94 to the north, Forest Avenue to the south, St. Aubin Street to the west and Chene Street to the east—is the metal shed that formerly housed Chene-Ferry Market. The market operated from 1850 to 1990 and, along with

ABOVE A ghost sign for the E. Donaldson automotive sales business lines a vacant building at the southwest corner of Chene and Palmer Streets.

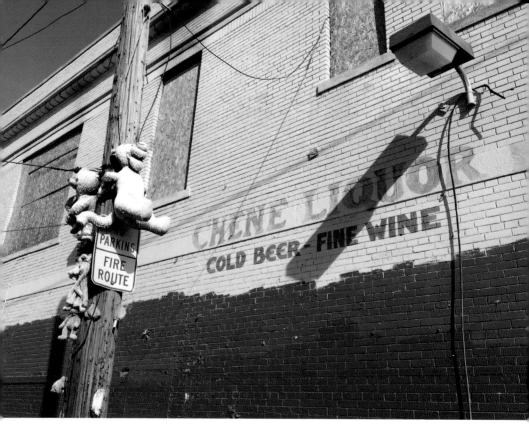

the Eastern and Western Markets, provided fresh, locally grown produce to Detroit's residents as the city grew. In 1926, Adam Olejnik, a Polish immigrant, started a farm outside the city, in Macomb County, that sold at Chene-Ferry for decades. The *Detroit Free Press* interviewed Lottie Olejnik, his daughter-in-law, for a story that published in 1981: "It used to be that every stall in the market shed was taken, Mrs. Olejnik said, and many farmers had to stand outside to sell their goods. Crowds were so big you could hardly move."

By the 1980s, the farm, and the other vendors that remained, struggled. The market "has been hurt badly by the destruction of the surrounding Poletown neighborhood....In this era of giant corporate farms and mechanical harvesting, produce warehouses and supermarkets, the Olejnik farm may seem like a throwback. It's a

ABOVE A memorial adorned with fading stuffed animals is seen on a power pole near the boarded-up, closed Chene Liquor store on the southwest corner of Chene and Ferry Streets.

OPPOSITE, TOP A Lauder's Scotch advertisement is visible on a vacant building on Forest Avenue near Flower Court.

OPPOSITE, BOTTOM A former shed housing Chene-Ferry Market is long dormant since the market stopped operations in 1990.

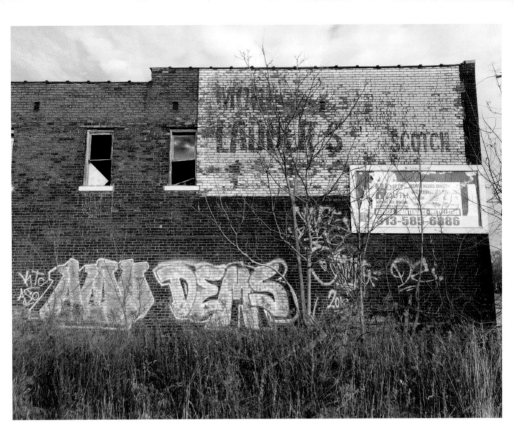

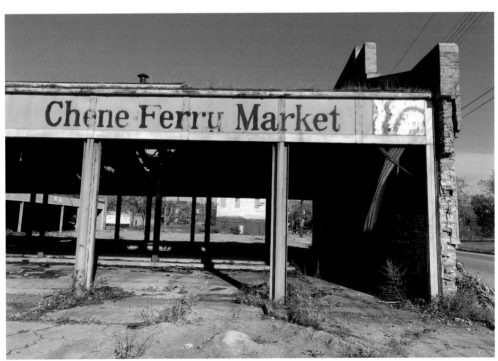

A psychedelic mix of cartoons welcomes visitors to Eastern Market along Gratiot Avenue north of Rivard Street.

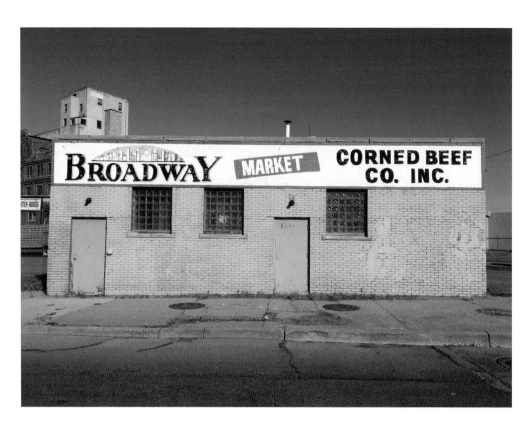

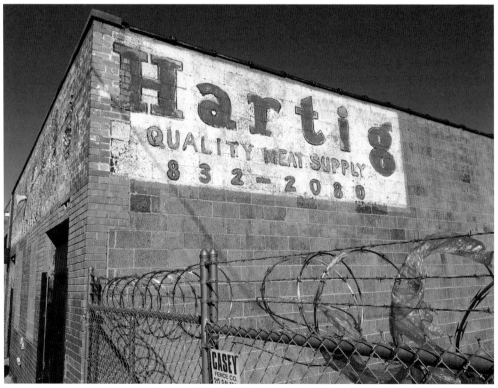

family farm, sixty acres planted in tomatoes, peppers, melons, corn, cucumbers, cabbages, carrots, potatoes and beans," according to the report.

Despite the changes, Olejnik Farms remains in business thirty-six years later as a fourth-generation farm, at the same site on 23 Mile and Card Roads in Macomb County. Richard Olejnik, Adam's grandson, was one of seven siblings who helped with the farm work since childhood. He remembers standing up in a truck as a young boy and watching the wall-to-wall customers. "In the alley, they'd be selling chickens and ducks," said Richard Olejnik, now sixty-six, recalling how his grandparents would speak in Polish with many of their customers. "It was alive. And the whole market was filled up."

Through the years, people moved away and longtime residents died. In about 1980, the city demolished 1,500 homes, businesses and churches, relocating 3,400 people to clear space for the General Motors plant north of Interstate 94, the *Detroit Free Press* reported in 1985. Around the intersection of Chene and Ferry Streets, it became like a ghost town. Weeds grow through cracks in the pavement and even on the roof of the market shed, which has holes and pieces of metal hanging from the ceiling. "Now you go there, and it makes you want to shed a tear," Olejnik said.

He, like several of his relatives, also worked for the Detroit Police Department while helping with the farm. Now retired and a grandfather, he has a son who's followed in his footsteps, policing and farming. "Back to our Chene-Ferry days, we probably did 5 percent of what we do now," Olejnik said, adding that they now have more than 100,000 square feet of greenhouses. "We have a farm market that's open every day. That's kind of our main store."

Olejnik Farms continues to sell produce, as well as potted plants, at farmers' markets in Royal Oak and Pontiac. Until about five years ago, it was selling at Detroit's Eastern Market, about a mile south of Poletown. That market, just outside of downtown, flourished in recent years, with weekend crowds and the addition of restaurants, a

OPPOSITE, TOP The sign for Broadway Market Corned Beef Company, operating at 1841 Gratiot Avenue, is seen here.

OPPOSITE, BOTTOM A sign for Hartig Quality Meat Supply is seen at 1525 Division Street.

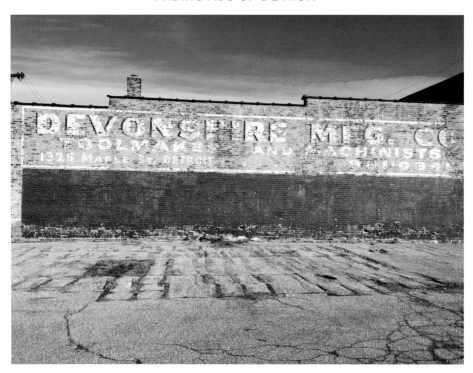

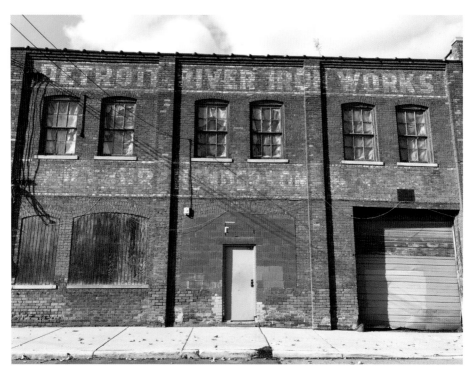

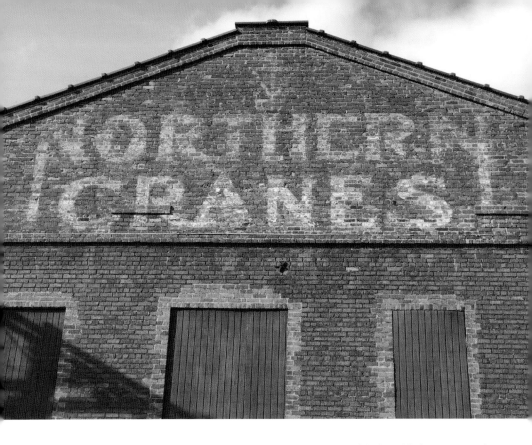

distillery and a brewery. Olejnik said they stopped selling there because there were already so many vendors.

He hadn't heard of the Recovery Park plans for Poletown East. I gave him some details, and he said the soil in the area is great for farming. But making such an operation viable would be challenging. "I'd like to see that succeed," he said. "I tell you, sometimes, driving through these neighborhoods, I'll sit and think I could drop a plow on a lot of this. All you gotta do is get the cement out of there."

Olejnik also observed firsthand the growth of the farm-to-table movement. "There has been a buy-local trend, it seems, lately," he said. "For one thing, we can offer stuff fresher than any supermarket. [Customers] say they would rather support their local farm. People, they beg us, 'Please, don't ever sell. Please, be here.'"

The colorful sign for a vacant place called the Kids Kandy Store is seen on East Warren Avenue west of Garland Street.

SWEETS AND SWEETHEARTS

ONCE FILLED WITH AROMAS of caramel popcorn and melting chocolate, the former home of Sydney Bogg Chocolates on Woodward Avenue and 7 Mile Road is deserted. "It's a mess in there—it's basically destroyed," said Debbie Schlicker, fifty-eight, who started working there at fourteen and visited the property in 2017. "I actually cried, it was so bad. It's gutted."

Founded in 1936, the company once had four candy stores across Metro Detroit. People craved the chocolate, caramel and pecan "turtlettes," as well as the Nutty Buttered Corn made with a caramel glaze over popcorn and nuts. For Christmas, there would be a fifty-pound chocolate Santa Claus in the window, surrounded by hanging candy canes. Employees would work an enrober machine that coated chocolate, using a conveyor belt reminiscent of the iconic *I Love Lucy* episode in which Lucy and Ethel get jobs at a candy factory.

The former home of Sydney Bogg Chocolates, from 1936 to 2002, is seen on Woodward Avenue south of Brentwood Street. Former employees have since opened a new location at 3233 Twelve Mile Road in Berkley.

MADE CANDY

FACTORY & STORE

SINCE 1936

CHOCOLATES

PARTY CANDIES

ROASTED NUTS

GL

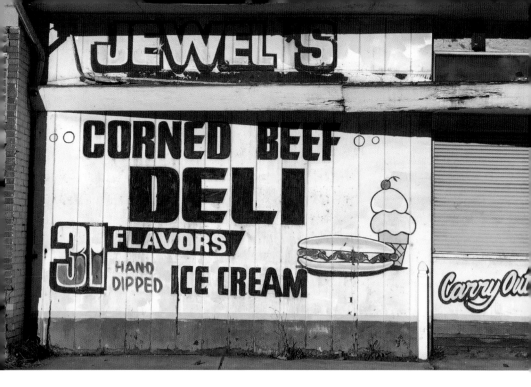

ABOVE The dormant location for Jewel's Corned Beef Deli is seen along Gratiot Avenue south of Wilfred Street.

Schlicker's husband, Gary, started working there at age fifteen. He went into the Marine Corps, and when he returned home a few years later, he went back to the candy factory. He was working as a molder—making chocolate molded into shapes—when he told his boss he needed an extra hand. "He said, 'Borrow whoever you want,'" said Gary Schlicker, now fifty-seven. He picked Debbie. "It was like a blink of an eye, she transformed the molding room."

Love sparked. "It wasn't long that we were acting like we had known each other forever," he said. They got married in 1985, and they continued working at the candy store until bankruptcy closed it in 2002.

Fifteen years later, the building remains eye-catching to drivers northbound on Woodward Avenue. Beneath a bright-red "Home Made Candy" banner is an image on brick showing the outline of a man stirring what appears to be a massive cauldron. The man is Bogg, the company founder and immigrant from England who arrived in Detroit in the 1920s. "If you knew the man, Sydney Bogg, he was so sweet and kindhearted," Debbie Schlicker said.

Bogg started out working for a refrigerator company. But curious to learn how candy was made, he apprenticed under Howard Vair, owner of Vair-E-Best, a Highland Park candy factory. Bogg started off selling the candy at night on city buses, his daughter, Joyce Thewalt, said in his obituary published on February 11, 1988, in the *Detroit Free Press*.

Bogg's store opened during the Great Depression (1929–39), and he would sell one piece of candy at a time so people could afford the sweet comfort food, Schlicker said. Bogg sold the company to Ralph Skidmore, a former employee, in 1969. Beyond the Detroit factory and store, the company opened stores at Great Oaks Mall in Rochester, Village Knoll Market in Birmingham and Holiday Market Center in Royal Oak. The company changed hands again in the 1990s before it went out of business.

The closure was so abrupt that Debbie Schlicker said she didn't have time to get the photos of her kids off her desk. A short time later, she received a call on her cellphone. It was a former customer. "I don't have a clue how they got my number," Debbie said. "She begged me, she was crying, she said, 'Nobody makes Sydney Bogg candies.' She said, 'My daughter's getting married, and I have to have it.'"

At their Madison Heights home, Debbie and Gary whipped up the order: sweet barks, chocolates and nonpareils—a flat, small, round candy on which Debbie designs names in icing. "She gave my number out at that wedding," she said. "My cellphone number was the company line for a while."

It wasn't long before they were making seventy-pound orders on their home stovetop. They got help from her sister, Lisa Peasley, who did the chocolate-dipping, while Gary did the cooking. And they were able to buy the equipment, kept under padlock, from the new owner of the Detroit building. Among the machinery was a fire mixer from about 1912, a cream beater from 1901 and a guillotine-style caramel cutter from about 1872.

In 2005, the former employees opened a storefront business on 3233 West 12 Mile Road in Berkley. Later, they were able to secure the original name, calling it Sydney Bogg's Sweet Essentials. The recipes are the same. And the source of their chocolate, which arrives packaged in big ten-pound bars, is the same: Peter's Chocolate, which was founded by Swiss chocolatier Daniel Peter, known as the inventor of milk chocolate, with a formula that was adopted in 1887, according to the What's Cooking America website. The new Sydney Bogg has continued to grow, and Debbie Schlicker said that she hopes at some point they can bring the name back to Detroit.

SANDERS

Like a box of chocolates, the outer shells of buildings conceal treats of their own. In the summer of 2017, crews removing the façade of a downtown building along Woodward Avenue uncovered a big sign for Sanders.

The company known for its bumpy cake and fudge topping was founded by Fred Sanders in Detroit in 1875. It grew to more than fifty-seven stores in Metro Detroit, but financial problems led to all of them closing by the early 1990s. The brand was sold, and Morley Candy Makers was the most recent company to purchase it, in the early 2000s, as the *Detroit Free Press* reported.

For Caroline and William Seelinger, the discovery of the sign was connected to sweet memories. "He was a stock boy, and I was a waitress," she said. They were both sixteen years old, and it was 1952. They were working at a Sanders restaurant in Highland Park. "I asked my supervisors who the new stock boy was, because I was enthralled by his looks. He reminded me of Elvis—I'm a big fan of Elvis."

They got to know each other. He asked her out on a date. They went roller skating and took a few trips to the movies. He went into the U.S. Navy, and they got married. After some time in San Diego, they moved back to Metro Detroit. They owned a few bars called the Shanty. And in 1985, he started Oakland Pest Control, which their son now runs. The Seelingers look forward to celebrating their sixtieth wedding anniversary in August 2018. "We still buy Sanders hot fudge for ice cream—love it," Caroline said. "I love the chocolate-covered cherries myself. He likes, more or less, kind of caramelly things."

RIGHT A sign for Sanders Candy is exposed in summer 2017 on Woodward Avenue north of Clifford Street in downtown Detroit.

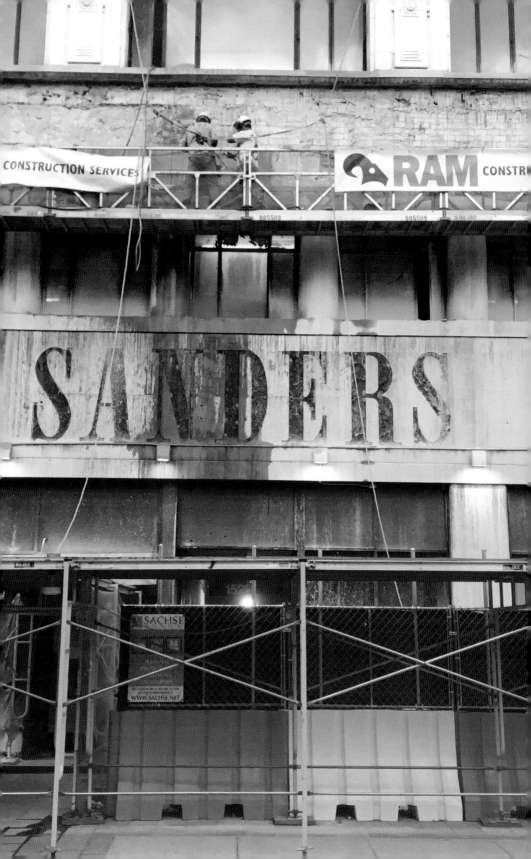

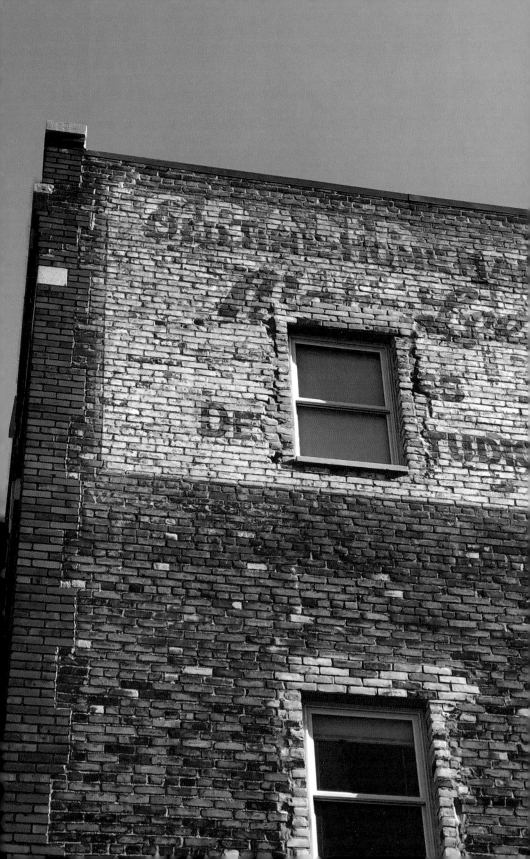

MARY LEE CANDIES

A wave of candy makers opened across the city in the first half of the twentieth century, each claiming to have the best homemade treats. "Most Good Homes Will Provide Mary Lee Old-Time Homemade Candies at the Yuletide Festival for Little Folks and Their Elders; These delicious sweets are all made in our own Studio under the most delightful home-like conditions, from the purest and most wholesome materials obtainable, blended by experts in the art of Home Cooking," according to a 1920 newspaper advertisement offering candy at eighty cents per pound.

Mary Lee Candies grew rapidly. Within a few years of opening on Woodward Avenue and Columbia, it had opened several other locations in the city, as well as in Grand Rapids, Flint, Lansing and Cleveland and Toledo, Ohio, according to a newspaper advertisement in 1923. "The goodness of Mary Lee Candies, together with the dainty refinement of the shops, have brought the Mary Lee Candy Shop from its humble beginning to the point where the Mary Lee Candy Shops have the largest retail sale of candy exclusively in the state of Michigan," according to the advertisement.

You can still see the signs on the four-story candy studio on a building near the southwest corner of Macomb and Beaubien Streets. In recent years, though, the signs have become obscured by holes made in the building for windows.

Like so many other businesses started in Detroit, candy shops had largely disappeared by the twenty-first century. But at a time when locally brewed craft beer and locally grown produce have become increasingly available here, locally made candies are also appearing: Bon Bon Bon in 2015 began offering artisanal chocolates made at a studio in Hamtramck. And shortly before this book went to print, the *Detroit Free Press* reported that former Ford Field executive chef Joe Nader announced plans for a chocolate bonbon storefront in the city.

LEFT The former studio for Mary Lee Candies is visible, despite the addition of a new window, on Macomb Street west of Beaubien Street in downtown Detroit.

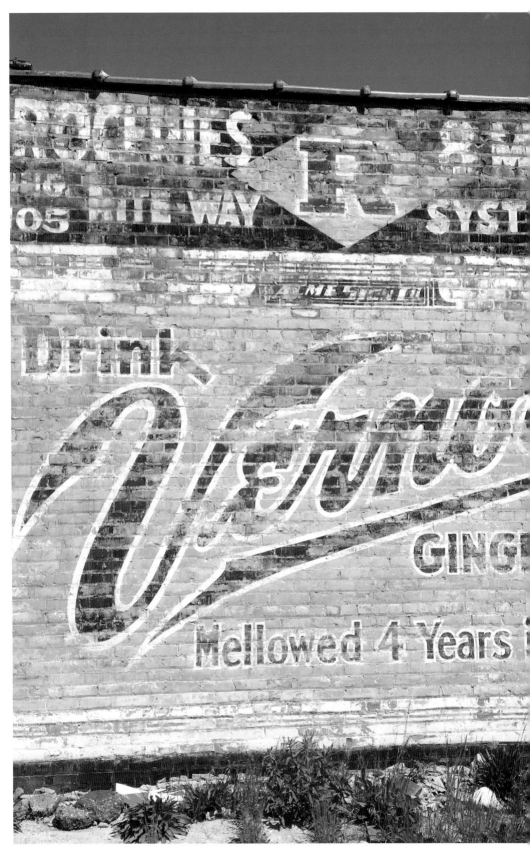

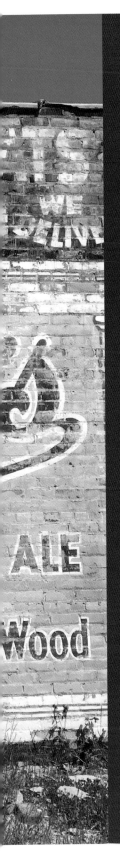

THE NAMES YOU KNOW

ONE OF DETROIT'S most stunningly well-preserved ghost signs was hidden behind a wall for decades, in a decaying shopping district along West McNichols Road near San Juan Drive on the city's west side. In mid-2015, the abandoned next-door building was demolished, among more than 120 that the city had taken down that year in a commercial-blight removal program. This exposed a green, white and red sign with a yellow-gold background on red brick that reads "Drink Vernor's Ginger Ale, mellowed four years in wood."

After just two years of sunlight, it has already begun to fade. Most of the nearby buildings along the block are closed and boarded up. Detroit mayor Mike Duggan stood in front of the sign in October 2017 to announce $125 million in funds to revitalize commercial corridors in neighborhoods such as this one.

While long-needed improvements to the city expose signs like this one, and destroy others, many of the brands named on them

continue to thrive. First available to the public in 1866, Vernor's Ginger Ale is still easy to find in Detroit. Detroit pharmacist James Vernor, who ran a soda fountain next to his pharmacy on Woodward Avenue, invented it.

"The doctor was working on a medicinal tonic of vanilla and spices, with the addition of ginger to calm the stomach, when he was called to fight in the Civil War. He left the blend in an oak cask and went off to fight in the Civil War in 1862. When Vernor returned from the war, he opened the barrel and was surprised by its delicious contents. The beverage had a zesty, sweet, gingery flavor that was accentuated by the wood's aging process," according to the Detroit Historical Society.

The drink grew in popularity across the Midwest, and the family business was ultimately sold to an investment group in 1966. Today, Vernors is owned by the Plano, Texas-based Dr. Pepper Snapple Group. But if you ask a lot of people who drank Vernors many years ago, they say it tastes much different. "The Vernors spared no effort or rigor to become a leader in the industry. That Vernor's Ginger Ale never matched the popularity of Canada Dry, Coca-Cola, Pepsi-Cola, or even Dr. Pepper may be because, as with licorice or sauternes, the taste for its delicious difference is one that not everyone can acquire," as Lawrence L. Rouch described in his book, *The Vernor's Story: From Gnomes to Now.*

If you have the chance, I highly recommend stopping by this sign for a visit. It's on the side of a vacant, sealed-up building, and it's unclear how long it will remain intact.

FAYGO

Virtually every Detroit party store carries products from Faygo Beverages, founded in 1907 in Detroit by brothers Perry and Ben Feigenson. An independent soda pop maker, it was known for Red Pop. It's now owned by National Beverage Corporation of Fort Lauderdale, Florida.

In the summer of 2017, billboards appeared in the city declaring "110 Years of Orange," for its popular Orange Faygo soft drink. Among many other flavors you're likely to see for sale here are Rock N' Rye, Dr. Faygo, Moon Mist Blue, Candy Apple and Pineapple Orange.

Faygo and Vernors are Detroit's two most iconic soft drinks. The former "reached a degree of success that Vernor's never attained," as the Feigensons had a "genius for marketing" and made it fun to drink Faygo, according to Rouch's book. He wrote that the business, known for sponsoring the Detroit Tigers baseball team, "relied heavily on advertising and mass-marketing, quickly capturing a thirty-state market. Their product line was more diverse, with root beer, orange soda and various fruit flavors, one of which was later marketed with the clever name of Red Pop."

BELOW A former advertisement for Faygo is obscured at the southwest corner of Mt. Elliott and Georgia Streets.

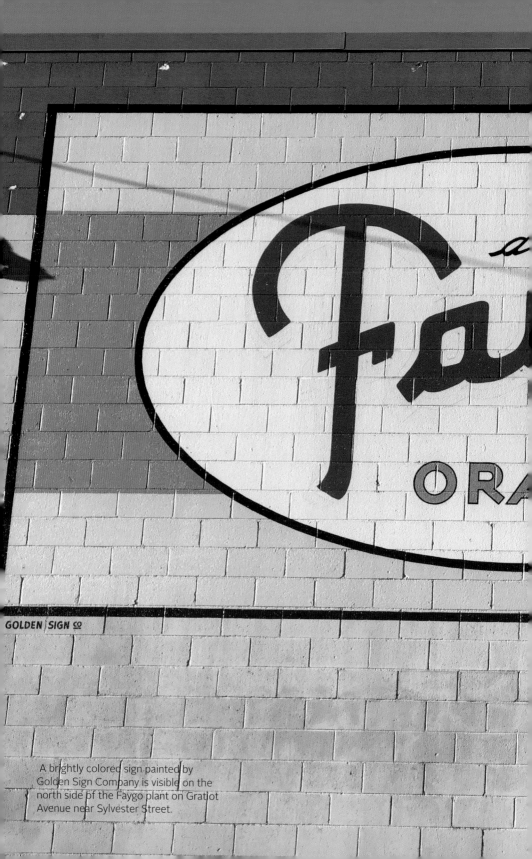

GOLDEN SIGN CO

A brightly colored sign painted by
Golden Sign Company is visible on the
north side of the Faygo plant on Gratiot
Avenue near Sylvester Street.

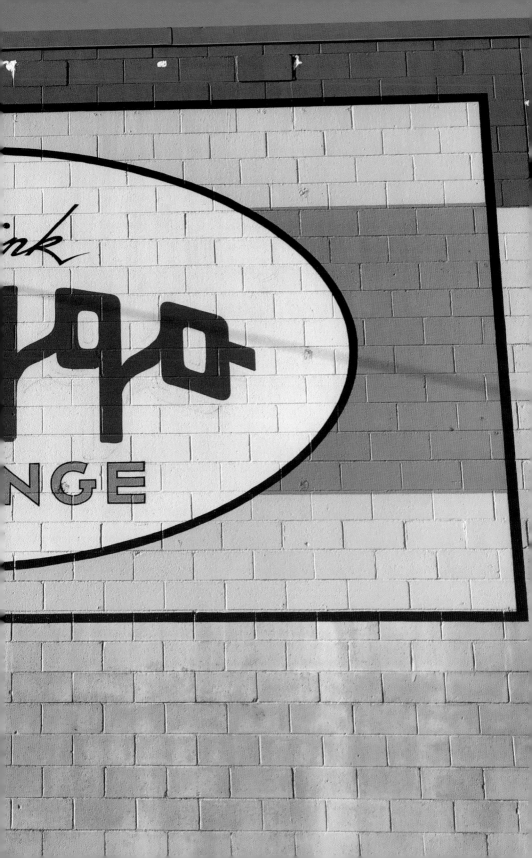

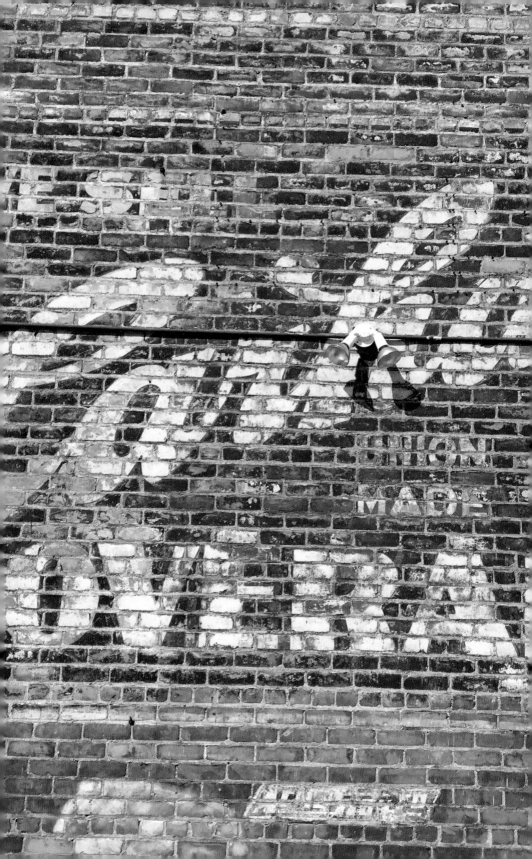

CARHARTT

I bought my first Carhartt coat shortly after moving to Detroit, and it's the best shield I've found against the biting cold winds that rattle bones for too much of the winter here.

The company was founded in 1889 by Hamilton Carhartt & Company "and began producing overalls with two sewing machines and a half-horsepower electric motor in a small Detroit loft. Early failures led Hamilton to focus heavily on market research, and after talking directly with railroad workers, he designed a product that truly fit their needs," according to its website.

The company by 1910 had grown to include mills in South Carolina and Georgia, with sewing facilities in Atlanta, Detroit, Dallas and San Francisco. Soon, it was in Toronto, New York and Paris. Carhartt made uniforms for the U.S. military in World War I and II. Today, the company employs more than five thousand people, with operations in the United States, Mexico and Europe, according to its website. The Carhartt headquarters is now in Dearborn. But in 2015, it opened a store in Midtown Detroit on 5800 Cass Avenue. You can see its wide "Born in Detroit 1889" mural along the north side of the building facing Interstate 94.

Long-faded advertisements for Carhartt can be seen across the city, including one on an old brick building at West Warren Avenue and Proctor Street on the west side and another on Kercheval Avenue and Eastlawn Street on the east side.

LEFT A faded sign advertising Carhartt overalls is seen on Kercheval Street east of Eastlawn Street.

STROH BREWERY COMPANY

On red brick, with the blurred lines of an old, sun-damaged tattoo, there's a sign visible behind some overgrown bushes on Van Dyke near Merkel, about one mile east of Hamtramck. On first glance, only someone familiar with the brand would recognize it: Stroh's—in this case, Stroh's Ice Cream. But the font is the same one you'll find today on Stroh Brewery Company beer bottles.

The next-door unit on the same structure was Cloverleaf Bakery before it went out of business. The building contained a bakery at least as far back as the 1960s, and it's no stretch to consider that the local brand of ice cream—still widely available today—was sold right along with cookies and brownies.

The beer dates to 1850, when German immigrant Bernhard Stroh started a brewery in Detroit. First called Lion's Head Brewery, the business would become the Stroh Brewery Company in 1902, when Stroh's son, Bernhard Stroh Jr., took over upon his father's death. The ice cream brand exists because of Prohibition (1920–33), when the beer company got by selling soft drinks, malt products, ice and other non-alcoholic consumables, according to *Brewed in Detroit*, a book by Peter H. Blum. Stroh's also was the only one in Detroit licensed to make low-alcohol "near beer" during Prohibition. When the national ban on alcohol ended, the company already had full-strength beer ready for packaging. So it had a head start on the competition, Blum wrote.

Into the mid-1980s, Stroh's would become the third-largest brewery in the United States. TV commercials about its "fire-brewed" product were a big hit, especially in Detroit. But by the late 1990s, issues such as debt from purchasing other brands, competition and flattening sales in the beer industry had led to the company's decline, as Frances Stroh wrote in her book, *Beer Money: A Memoir of Privilege and Loss.*

The original Detroit brewing location in the Eastern Market area closed in 1985 because it was "landlocked and unable to expand operations to meet growing demand," according to the Stroh's website. That space is now occupied by Crain Communications, publisher of *Crain's Detroit Business* and similar weeklies in Chicago, Cleveland and New York. In 1999, Stroh, a family-owned company since its founding, sold most of its brands to Pabst Brewing Company, the largest American-owned brewing business. Stroh's Lager today is brewed in Trenton, Ohio.

But since 2016, Stroh's beer is again made in Detroit—or at least one of its varieties. With the craft beer boom biting increasingly large chunks out of the market long dominated by Pabst and other macro-brewing companies, Stroh's Bohemian-Style Pilsner has returned and is only available in Michigan. It comes in

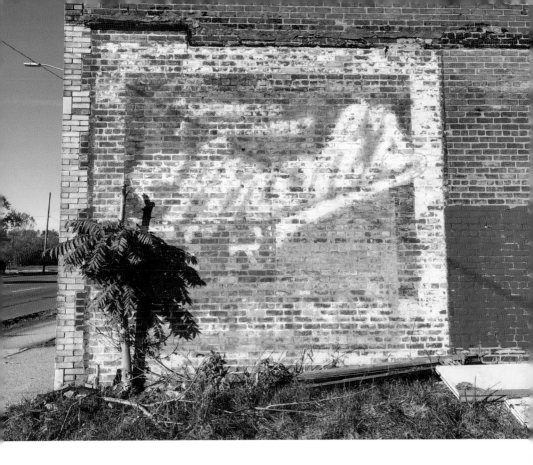

vintage-looking glass bottles with the classic insignia and Lion's Crest logo on a circular, red, black and yellow label that tastefully causes it to stand out from Stroh's Lager. The pilsner is an all-malt beer, meaning no corn-based adjuncts found in cheaper beer such as the lager and many other mass-produced domestic brews classified as American lagers. Pabst contracts with Brew Detroit, a craft brewery in Corktown, just west of downtown, to make the pilsner. Its bolder hops flavors, fuller body and lingering lacing put the pilsner firmly in the same flavor league as quality craft beers.

MR. BELVEDERE

People who lived in Metro Detroit in the 1960s and 1970s are likely to remember the line, "We do good work," spoken in so many TV commercials by "Mr. Belvedere," Maurice (Bud) Lezell, the owner of Belvedere Construction. "Lezell's trademarks [were] an almost comically deadpan style," and he became "a folk hero of local commercial TV, radio and newspaper advertising," the *Detroit Free Press* reported in March 2017, shortly after Lezell died at ninety-five.

He was born in 1921, in Crittendon, Kentucky, to Russian Jewish immigrants, and the family moved to Detroit when he was four. After high school, he served in the U.S. Coast Guard in World War II, and after the war, he took a six-month business school program in Detroit from the University of Michigan. He began selling storm windows and, in 1948, started his own home improvement company, according to a report in the *Detroit News*. He had previously told the newspaper he chose the name "Mr. Belvedere" as a nod to well-known movies about a British butler. "It just had a good ring to it," he told the newspaper. "Belvedere was someone who did good things for people and made them feel good."

People wore T-shirts with images of Lezell, asked for his autograph and even held a look-alike contest, the *News* reported. When he retired in 2004, Lezell sold the company to his employees, and it's since gone out of business. In 2017, the black, deteriorating sign for Belvedere Construction could still be seen Livernois Avenue, a few blocks south of 8 Mile Road.

RIGHT The big, black sign for the former location of Belvedere Construction is visible along Livernois Avenue south of Chippewa Street.

BETTER MADE POTATO CHIPS

If you're driving on Gratiot Avenue with the windows down a few blocks north of Interstate 94, you may notice the delicious aroma of potato chips being made.

Better Made Potato Chips was founded in 1930, when it was merely one of thirty-one potato chip companies in Detroit, as reported on April 12, 2017, in the *Detroit Free Press*. That day, the company was replacing its sign with a brighter red one. And Better Made was one of about three potato chip companies still operating in the city.

Better Made was started by two Sicilian immigrants, Peter Cipriano and Cross Moceri, near the beginning of the Great Depression. It offered its chips at a nickel per bag," the *Detroit Free Press* reported in 2015. Company officials and Cipriano family members say quality, customer loyalty and perseverance have helped keep Better Made in business. "They shouldn't be here, for all their ups and downs, but they are. There's this big, giant Frito-Lay...but here's little Better Made, fighting the good fight, always trying, never giving up," Karen Dybis, author of *Better Made in Michigan: The Salty Story of Detroit's Best Chip* (2015), told the *Free Press*.

The company, with 250 employees, processes 50 million pounds of potatoes per year from the location on Gratiot, getting a potato from bin to bag in only seven minutes, according to the article. The chips can be found in delis, grocery stores and party stores across Metro Detroit and far beyond, with help from online orders.

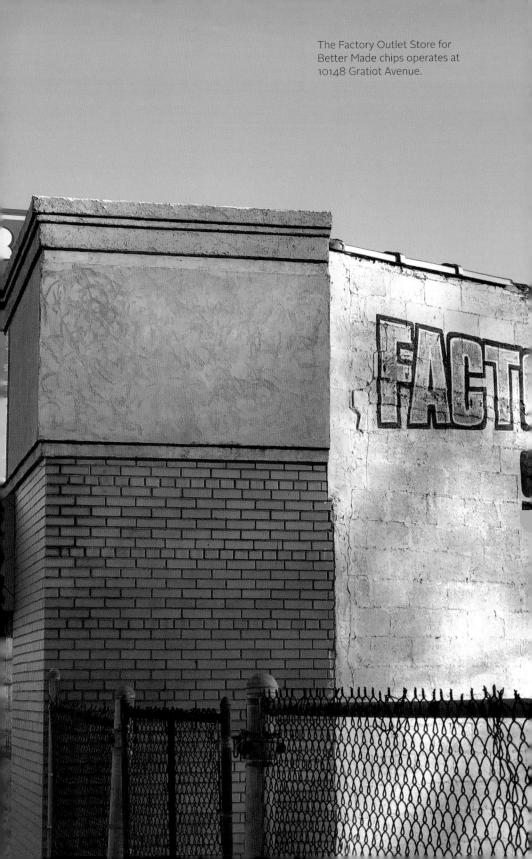

The Factory Outlet Store for Better Made chips operates at 10148 Gratiot Avenue.

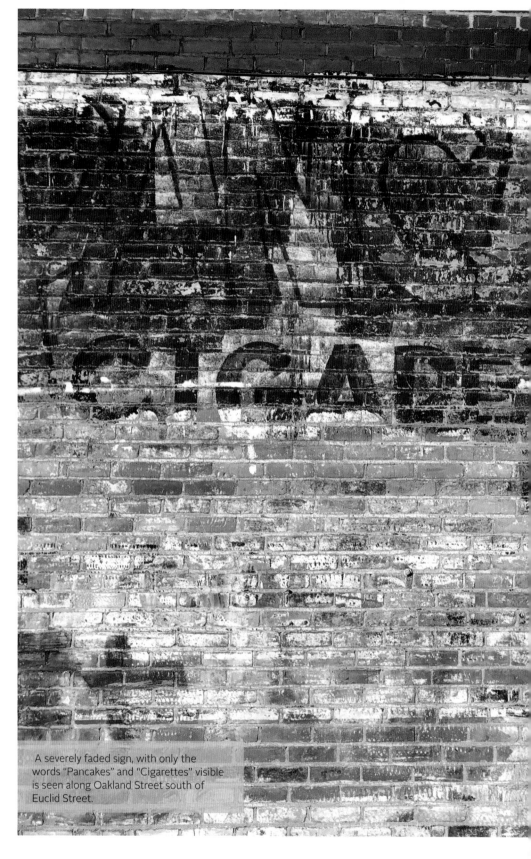

A severely faded sign, with only the words "Pancakes" and "Cigarettes" visible is seen along Oakland Street south of Euclid Street.

WALL DOGS

JOHN KING FOUND an "itinerant, egotistical maniac," "a semi-bohemian, narcissistic knucklehead" in the early 1980s to paint the name of his bookstore, freehand, along the top of his four-story building in downtown Detroit. "He hung down over the building with a parachute harness and painted the sign upside down," King said. "And he didn't like working during the day, because he liked to sleep during the day. So he did it at night. And the police helicopter came by and thought he was a jumper."

The painter demonstrated for police that he was, in fact, painting, and he resumed his work. King said the quirky man did good work, charging $750. When the painter, named George, needed money, sometimes he'd show up at the bookstore and offer to do a sign. "He'd find a board in the garbage and show up with a board that was like, a piece of shit, and he would paint over it to make it look nice. And then he would paint the sign on it," King said. "He was a really low-cost guy. He drove an old, crappy car and he was like, he had all these weird opinions about stuff."

The stories of sign painters, known colloquially as "wall dogs," date back more than one hundred years, as wall advertising peaked between 1890 and 1950. William

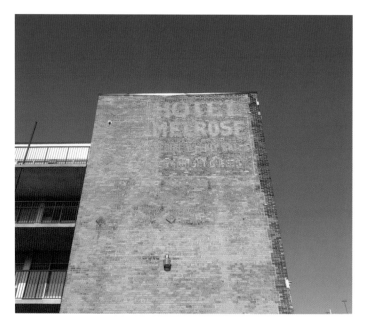

TOP A heavily faded Dog Hospital sign is visible on Woodward Avenue north of West Dakota.

ABOVE The long-faded sign for Hotel Melrose is visible along Canfield Street west of John R. Street in Midtown Detroit.

RIGHT A faded advertisement for Pepsi is seen along the west Southfield Freeway service drive south of Westfield Street. The sign has since been painted over.

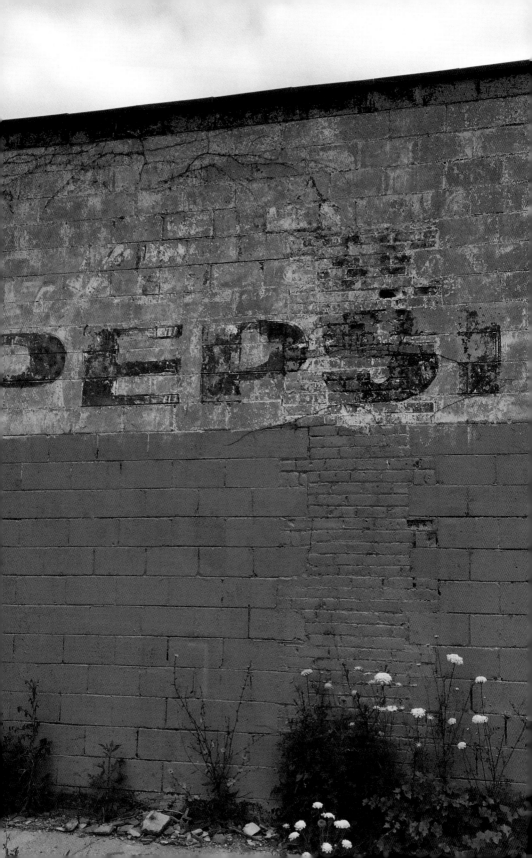

Stage, who's traveled the United States writing about sign painters, described them in his book, *Ghost Signs: Brick Wall Signs in America*.

Sign painters would spit tobacco juice from their scaffolding atop twenty-story buildings and would "slide apeman-fashion down the ropes and falls, either from the roof of a building to the scaffold below, or from scaffold to the street. This was known as a 'roof swing' and at one time was common practice among wall dogs," Stage wrote. Before lead paint was banned in the 1960s, sign painters would develop what became known as "painter's colic," or lead poisoning.

Hand-painted wall signs decreased in popularity as highway systems developed, receiving far more traffic than the old city streets. Instead, billboards were used, as they were "easier to maintain, to illuminate and to change," Stage wrote. Vinyl signs, which can cost less than half the price of a hand-painted sign and grew in popularity in the second half of the twentieth century, now dominate many shopping districts across the country.

Hand-painted signs were at their peak at about the same time as Detroit's population reached its peak, near 1.8 million people in 1950, according to U.S. Census data. Residents moved out of the city in the ensuing decades, and the population declined to about 672,795 people in 2016. This left the city with about eighty thousand abandoned buildings by 2014, according to an estimate reported by National Public Radio. That's a lot of old signs.

More than a dozen of the ghost signs in this book were exposed after a neighboring structure was scraped and the long-covered brick wall exposed. They're colorful, easy-to-spot pieces of history that often disappear just as easily. I saw this firsthand when backhoes tore down the sign for Kovacs Bar in Delray. In another instance, I cringed at realizing, after driving back and forth several times on a stretch of East Warren Avenue, that the blue Mohawk Liquor sign I was seeking to photograph had disappeared. A third disappointment struck after driving half an hour to Telegraph Road to shoot a Pepsi sign with the pre-dusk sun exactly where I wanted it. Alas, the sign was freshly painted over.

KLEIN SIGNS

Dave Klein has painted many of Southeast Michigan's Coca-Cola walls. His company, Klein Signs, was started by his father in 1933. Dave Klein, now fifty-nine, said he had helped his dad since age seven and later took over the business. "I couldn't wait to get home from school to go paint with my dad," he said, adding that while other kids were out playing, he'd be working on walls with his father. "This is all I've done my whole life."

They'd make hand-painted signs for gas stations, party stores, schools, restaurants, car washes, delivery trucks and the hydroplanes that race on the Detroit River. Even in winter, they worked. "I would never do anything else," Klein said. "I've had guys that come up to me that cut vinyl. It just doesn't

BELOW A faux Talking Dolls storefront was painted among several others by Klein Signs and GVC Painting for the former Toys Warehouse on Van Dyke Street, south of East Davison Street.

interest me to get a machine. I think there's no skill in that."

In about 2002, he teamed up with GVC Painting of Milford to paint the entire east-facing side of a two-hundred-foot-long warehouse along Van Dyke, south of East Davison Street, on Detroit's east side. The multicolored wall face for Toys Warehouse features a series of fake storefronts for "Scooters," "Games," "Radio-Controlled" and more, each with their own painted-on doors and windows. The mega-sign is still there. But the business isn't.

"We did that in about six days," Klein said. "That guy only opened one month, November, then he finally closed it all up. He used to do a high, high volume. I can't believe the people that would come through there. He had low-budget toys in there."

ABOVE A sign for Eastern Michigan Distributors Company was painted by Klein Signs at the southeast corner of Mt. Elliott and Farnsworth Streets.

The building had previously been a lumber company and public auction space. Spending so much time outdoors, Klein's had a spectrum of odd experiences. "One time, I was working on a billboard, and a dog came up to me," he said. "I gave him a couple snacks. I took him home." Klein gave the dog away to a friend who owned gas stations across the city. "He took him to the vet: 45 percent wolf," Klein said, adding that the friend "loved him as a guard dog" and kept him for eleven years.

Klein said he knew of wall dogs who'd climb over the roof of an eight-story building and slide down a rope to get to their platform. When they were done, they'd find an open window and use that to get back down, he said. Klein said he knows of painters in their nineties who are still doing it. "[My father] always used to say, 'Sign painters don't retire. They paint until they die,'" he said. And when his father died at age seventy-five in 1991, he put a couple new painter's quills in his coffin. "I said, 'He's going to paint some signs in heaven.'"

MAIL POUCH TOBACCO

Seen in pristine condition on a western-facing brick wall along Michigan Avenue, the Mail Pouch Tobacco sign through most of its history was found on thousands of barns.

The brand dates to 1879, when brothers Aaron and Samuel Bloch began making cigars in Wheeling, West Virginia. They started using stogie wrapper clippings for chewing tobacco, calling it West Virginia Mail Pouch, Carole Gilbert Brown reported in 2008 in the *Pittsburgh Post-Gazette*. "The chew was a hit. In 1890, the Blochs began to advertise their product on the sides of businesses that sold it. By 1925, they had moved on to barn advertisements," Brown wrote. "By the early 1960s, about 20,000 Mail Pouch barns were spread across 22 states."

BELOW A wall sign advertising Mail Pouch Tobacco is seen in pristine condition after it an adjacent building was demolished, recently exposing it on Michigan Avenue east of Homedale Street.

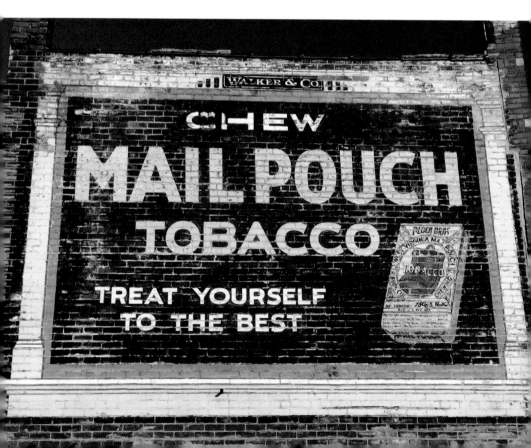

A campaign against putting signs on barns included Michigan, and the painted signs were determined to be billboards under the state's 1972 Billboard Control Act—requiring all of them to be removed. The government at the time gave farmers two options: paint over the ads themselves or let the state do it for free—but the state wouldn't pay to paint the other three sides.

At the time, there were estimated to be two hundred Michigan barns with advertisements on their sides, and three-fourths of them were tobacco ads, mostly for Mail Pouch, according the *Detroit Free Press* in 1973. The company had been paying farmers annually to keep the ads posted.

In an editorial, the newspaper at the time called for exempting them. "During the [Great] Depression, signs were the only way a lot of barns ever got painted. A plug of tobacco may be the only reason some barns are still standing," according to the editorial, which pointed out that historic, painted barn advertisements were already on the decline, thanks to the rise of expressways. "Left alone, the barn signs will fade, literally, from sight. But the state should leave them alone and let them die a natural death."

Barn-painting ended in about 2000, after the last living Mail Pouch barn painter died, according to Brown. Now, at least in Michigan, a Mail Pouch barn is a rare sight.

MOTOWN SIGN COMPANY

Standing on a platform on a hot afternoon in July 2017, Jordan Zielke created a Carhartt ghost sign in a style similar to what a painter would have made in perhaps the 1920s, 1930s and 1940s. "If somebody comes into Eastern Market who's never been here before, they're going to think this has been here forever," said Zielke, thirty.

That's how the client wanted it to look, on an old, nine- by eight-and-a-half-foot board set inside brick along the north-facing wall of Detroit Mercantile Company on 3434 Russell Street. For this project, he used one primer with two coats of black paint on the wooden board, followed by one coat of white lettering. He usually double-coats lettering, but he wanted it to look faded.

Zielke's company also created the gold-leaf sign used by Detroit Bikes (seen in this book's "Downtown" chapter), as well as the 125-foot Carhartt mural along the side of that company's Detroit store (as mentioned in "The Names You Know"). Started as Golden Sign Company in 2012, it used to be him and Kelly Golden. Now it's just Zielke. Trained in California at a trade school teaching sign painting since 1924, they did projects for numerous restaurants and other businesses across Metro Detroit, including for Bobcat Bonnie's restaurant in Corktown and rock star Jack White's Third Man Records. "If you want the top quality, this is where you get it," Zielke said.

RIGHT Jordan Zielke with Motown Sign Company paints an imitation vintage Carhartt overalls sign on the north wall of Detroit Mercantile Company at 3434 Russell Street.

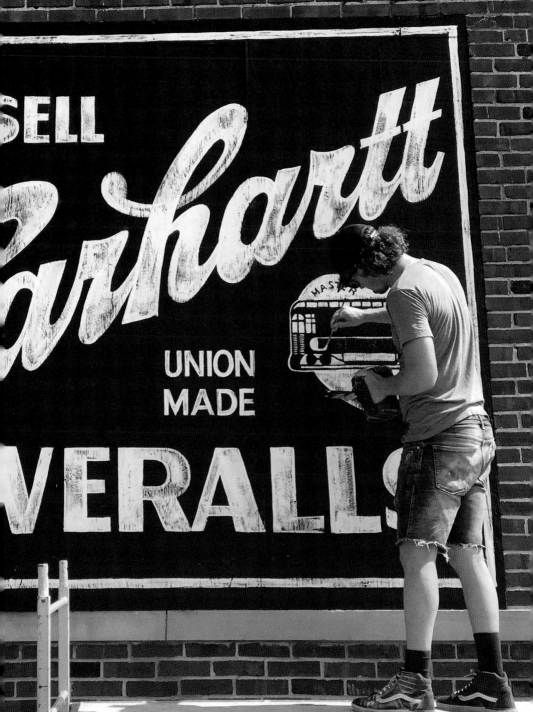

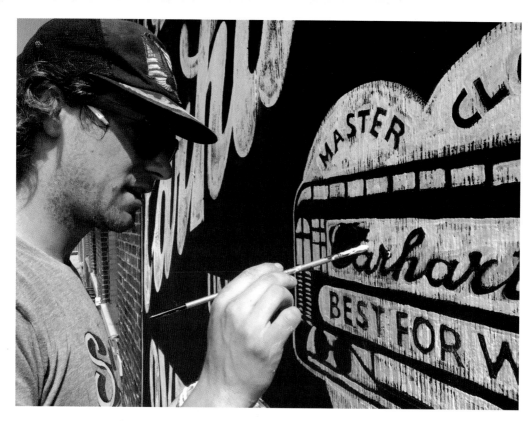

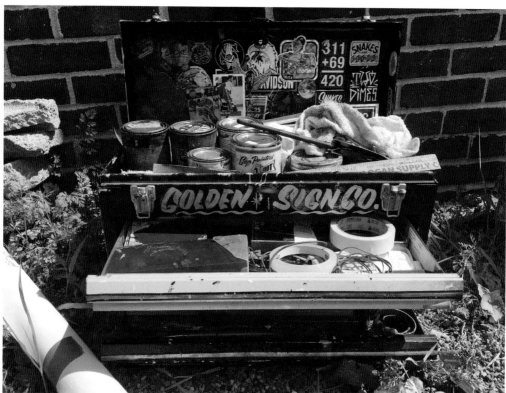

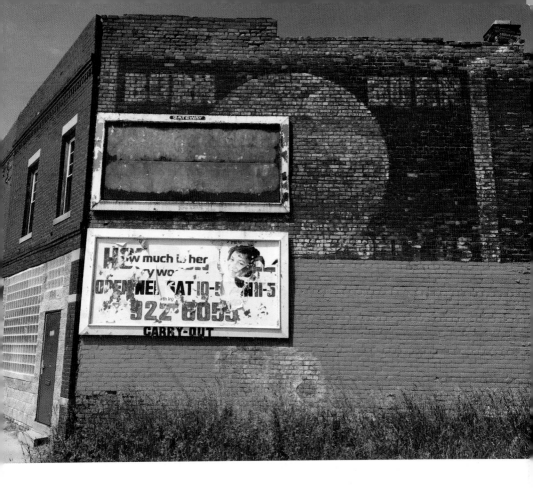

OPPOSITE, TOP Jordan Zielke with Motown Sign Company uses paintbrushes made of hog or squirrel hair on signs, including for this Carhartt overalls piece at Detroit Mercantile Company at 3434 Russell Street.

OPPOSITE, BOTTOM The painter's open toolbox is seen as Jordan Zielke with Motown Sign Company paints a sign outside Detroit Mercantile Company at 3434 Russell Street.

ABOVE A blur of ghost signs covered by newer and similarly indecipherable signs is seen along Gratiot Avenue south of Crane Street.

They learned from Doc Guthrie, a legendary sign painter, at Los Angeles Trade Technical College. Guthrie previously told me that for years, the number of people pursuing the art of sign making had been in decline. He'd been lucky to have twenty-five students. But by early 2016, he had seventy students, with a waiting list. And they're finding work. "Businesses are saying, 'I don't want that generic look—that stick-on look. I want that real look,'" he said in a *Detroit Free Press* article in 2016.

Zielke's sign making process is the same used by sign painters for decades, using a technology that hasn't changed much since the 1960s: an electro-pounce machine. It burns tiny holes in paper using an electric current between a

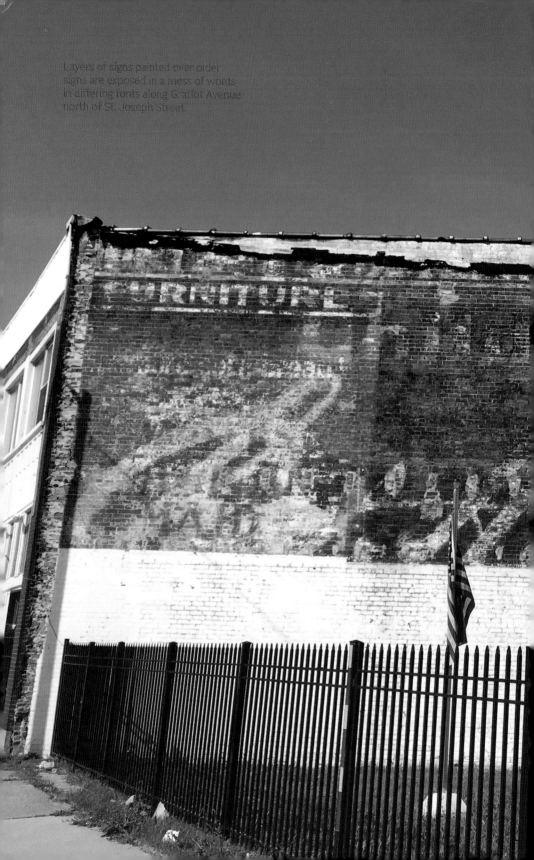

Layers of signs painted over older signs are exposed in a mess of words in differing fonts along Gratiot Avenue north of St. Joseph Street.

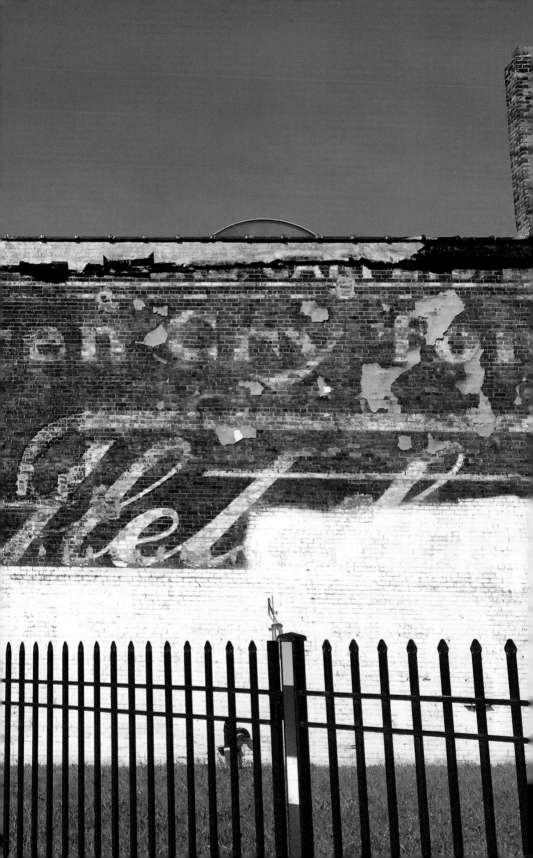

metal tip and a stainless steel sheet. The perforated paper is taken to the job site and posted over where the sign will be painted. "You rub a chalk bag, kind of pound it," Zielke said. The paper is rolled back off the wall, "and then you're left with your artwork, and that's how you fill it in." The image is painted using oil-based paint and brushes made of hog or squirrel hair, depending on the surface.

The owners of new businesses opening in old buildings often come to Motown Sign Company looking for an authentic, hand-painted sign. One issue Zielke has run into is brick decay. Pointing to the light-orange lower bricks on an old wall of mostly reddish-orange bricks, he explained that the former have endured the most weathering and are "turning to dust."

It won't hold fresh paint very well. "Once you break the surface, it's just coming off," he said. "Brick will hold up a lot better than wood, but nothing lasts forever."

SIGNS OFF

Detroit's recent upsurge—the rapid renovation of downtown high-rises, the new businesses, urban farms, upscale lofts— is exciting to watch. And I hope it continues. Of course, another recession could beat back the growth. It also seems a little precarious that a disproportionate share of the development is connected to only two to three major business entities. But others are joining them. As comes up in any serious discussion about change in the city, the area outside the roughly 7.2 square miles encompassing downtown, Midtown and their surrounding neighborhoods remains largely in bad shape. But the changes must start somewhere. And as much as I want to roll my eyes about eating dinner at places offering cocktails for ten dollars or more, I get that we need people happy to pay that. And it's exciting that so much of the renovations are preserving the historic architecture. That makes for more character than

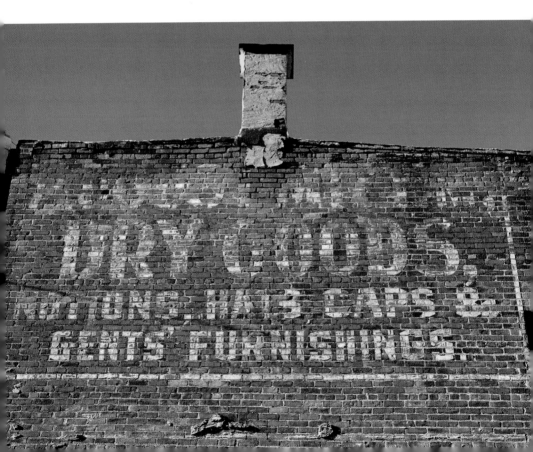

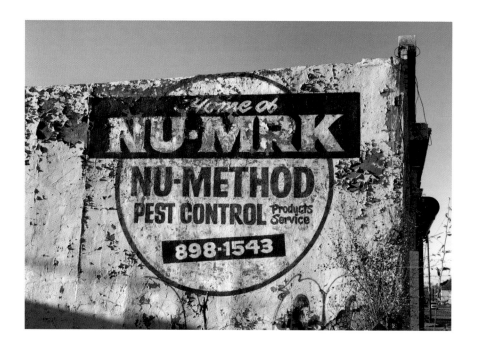

tearing it all down and starting over with taller, glass-lined boxes. The amount of change in 2017 alone really seems to indicate positive momentum.

While signs are this book's primary focus, graffiti artists and muralists from across the world have also been drawn to—and made substantial impacts on—the Detroit cityscape. These have included big names. Los Angeles–based graffiti artist Shepard Fairey, known for creating the *Hope* image of Barack Obama during his successful 2008 presidential campaign, created a 184- by 60-foot mural along the back of One Campus Martius in 2015 in downtown Detroit. There was a big hubbub over a Banksy painting discovered in 2010 on a cinder block wall among the debris of the decaying Packard Automotive Plant, with the illustration of a kid holding a paint can and the words, "I remember when all this was trees."

To some locals, that piece by the renowned, underground British graffiti artist was so valuable that they ripped the entire wall off the property and moved it to a gallery for preservation. And it is indeed financially valuable, as a bidder paid $137,500 for it at auction. Meanwhile, walls of ghost signs connected to the stories, the struggles and the triumphs in Detroit's blood get torn down, vandalized or sun-battered. Their existence is fleeting, but it's worth contemplating.

REFERENCES

Aguilar, Louis. "Sotheby's Halts Auction of Detroit Mosaics." *Detroit News*, March 1, 2016. http://www.detroitnews.com/story/business/2016/03/01/auction-detroit-stolen/81185938.

The Albert—Luxury Apartments in Capitol Park, Detroit. "Find an Apartment." http://www.thealbertcapitolpark.com/detroit/the-albert/floorplans.

Allen, Robert. "Artisanal Signs of Detroit's Renewal, Painted by Hand." *Detroit Free Press*, January 9, 2016. https://www.freep.com/story/money/business/michigan/2016/01/09/golden-signs-detroit-entrepreneurs/78497492.

———. "Fire Hydrant Hookup Keeps Downtown Café Percolating." *Detroit Free Press*, October 2, 2014. https://www.freep.com/story/news/local/michigan/detroit/2014/10/02/jury-rigged-fire-hydrant-keeps-downtown-caf-percolating/16564903.

———. "Henry the Hatter Owner Can 'Walk Away with a Smile.'" *Detroit Free Press*, June 30, 2017. https://www.freep.com/story/news/local/michigan/detroit/2017/06/30/henry-hatter-owner-can-walk-away-smile/442848001.

———. "Historic Candy Store Sign Uncovered in Downtown Detroit." *Detroit Free Press*, August 9, 2017. https://www.freep.com/story/news/local/michigan/detroit/2017/08/09/sanders-candy-detroit/551576001.

———. "1-Up: Detroit Video Arcades Ride '80s Nostalgia Wave." *Detroit Free Press*, September 29, 2017. https://www.freep.com/story/news/local/michigan/detroit/2017/09/29/detroit-arcade-bar-video-game/663449001.

———. "2 Detroit Businesses to Unplug from Fire Hydrant." *Detroit Free Press*, October 9, 2014. https://www.freep.com/story/news/local/michigan/detroit/2014/10/09/cafe-fire-hydrant-detroit-lawsuit-wurlitzer-blight/16974659.

Austin, Dan. "Farwell Building." *Historic Detroit.* http://www.historicdetroit.org/building/farwell-building.

———. "Recreation Building." *Historic Detroit.* http://www.historicdetroit.org/building/recreation-building.

———. "Tiger Stadium." *Historic Detroit.* http://www.historicdetroit.org/building/tiger-stadium.

———. "Wurlitzer Building." *Historic Detroit.* http://www.historicdetroit.org/building/wurlitzer-building.

Bailey, Sarah Pulliam. "This U.S. City Has Become the First to Elect a Muslim-Majority City Council." *Washington Post*, November 5, 2015. https://www.washingtonpost.com/news/acts-of-faith/wp/2015/11/05/this-u-s-city-has-become-the-first-to-elect-a-muslim-majority-city-council/?utm_term=.581ebbfd7d59.

Ball, Zachare. "Candymaker's Chocolate Was His Pride." *Detroit Free Press*, February 11, 1988.

Battagello, Dave. "Gordie Howe Bridge Project Faces Another Delay, Pushing Back Completion to 2023." *Windsor Star*, August 22, 2017. http://windsorstar.com/news/local-news/howe-bridge-project-delayed-up-to-another-year.

Bjorn, Lars, and Jim Gallert. *Before Motown: A History of Jazz in Detroit, 1920–60.* Ann Arbor: University of Michigan Press, 2001.

Blum, Peter H. *Brewed in Detroit.* Detroit, MI: Wayne State University Press, 1999.

Blythe, Samuel G. "A Stranger in Detroit." *Detroit Free Press*, September 24, 1905.

Brown, Carole Gilbert. "Demolition Uncovers Mail Pouch Ad." *Pittsburgh Post-Gazette*, July 24, 2008. http://www.post-gazette.com/neighborhoods-west/2008/07/24/Demolition-uncovers-Mail-Pouch-ad/stories/200807240325.

Business Wire. "Heaven Hill Distilleries Acquires Mohawk Distilled Products Spirits Portfolio." June 4, 2007. https://www.businesswire.com/news/home/20070604006252/en/Heaven-Hill-Distilleries-Acquires-Mohawk-Distilled-Products.

Carhartt. "Carhartt History." http://www.carhartt.com/content/carhartt-history?icid=LINK-about-history.

Carlisle, John. "Detroit's Last Pool Hall Tries to Hang On." *Detroit Free Press*, February 18, 2016. https://www.freep.com/story/news/columnists/john-carlisle/2016/02/17/detroit-last-pool-hall/80467114.

———. "Last Call?" *Detroit Metro Times*, October 21, 2009. https://www.metrotimes.com/detroit/last-call/Content?oid=2196051.

———. "Last Days: A Legendary Downtown Bar and Its Owners Remain Entwined Until the End." *Detroit Metro Times*, December 5, 2012. https://www.metrotimes.com/detroit/last-days/Content?oid=2146890.

———."Owner of Steve's Place Bar Dead at 90." *Detroit Free Press*, June 24, 2015. https://www.freep.com/story/news/columnists/john-carlisle/2015/06/24/owner-steves-place-dies-age/29219501.

Carman, Tim, Fritz Hahn and Shelly Tan. "America's Most Authentic Dive Bars." *Washington Post*, April 20, 2017.

Chesley, Roger. "Businesses, Service Groups Recycle Old Bowling Alleys." *Detroit Free Press*, June 24, 1994.

City of Detroit. "$15M Recovery Park Project to Transform 22-Block Area of Blighted Property into Urban Agriculture Enterprise." October 26, 2015. http://www.detroitmi.gov/News/ArticleID/522/-15M-Recovery-Park-project-to-transform-22-block-area-of-blighted-property-into-urban-agriculture-enterprise.

Clements, David. *Talking Shops: Detroit Commercial Folk Art*. Detroit, MI: Wayne State University Press, 2005.

Crump, Constance. "Art at the Heart of 4731 Building's Revival." *Crain's Detroit Business*, November 18, 2010. http://www.crainsdetroit.com/article/20101118/DM01/101119831/art-at-the-heart-of-4731-buildings-revival.

Dempsey, Jack. "Landmark of Liberty: Detroit's Capitol Park." *Michigan History*, January/February 2012. http://www.hsmichigan.org/wp-content/uploads/2011/12/Capitol-Park.pdf.

Derringer, Nancy. "In a Gentrifying Detroit, an Uneasy Migration of Urban Millennials." *Bridge Magazine*, August 21, 2014. http://www.bridgemi.com/detroit-bankruptcy-and-beyond/gentrifying-detroit-uneasy-migration-urban-millennials.

Detroit Free Press. Advertisement, "Auction—Furniture, J. Herman Store." April 18, 1931.

———. Advertisement, "Mary Lee Candies." December 17, 1920.

———. Advertisement, "Mary Lee Candy Shops of Detroit." May 11, 1923.

———. Advertisement, Mohawk Liquor Corp. February 8, 1936.

———. Advertisement, "PHILCO High-Fidelity Radio." September 13, 1934.

———. Advertisement, "Rathnaw's; the Original Bowling Outfitter." October 7, 1957.

———. Advertisement, Simmons and Clark Jewelers. October 5, 1942.

———. Advertisement, Wellman. December 25, 1929.

———. "Anthony Rathnaw, Clothier, Official." November 6, 1976.

———. Classified advertisement, "Al's Inn, Bar...12327 Gratiot." October 20, 1996.

———. Classified advertisement. "Auction—Furniture; J. Herman Store." April 18, 1931.

———. Classified advertisement, "Restaurant...12327 Gratiot." October 3, 1929.

———. "The 43 Who Died: An Investigation into How and Why Detroit's Riot Victims Were Slain." September 3, 1967.

———. "Fyfe & Co. Plans Handsome Store." October 21, 1917.

———. Obituary, Frank J. Kapanowski. February 20, 1998.

———. "Pity the Poor Bullfrog." July 28, 1907.

———. "Police to Wage Bomb Warfare." October 27, 1925.

———. "Poor Charley Bennett." June 23, 1894.

———. "R.H. Fyfe, Merchant Dean, Dies." October 28, 1931.

———. "Safety Gloves Guard War Workers." March 29, 1942.

———. "Story of Store Is Detroit Saga." September 8, 1940.

———. "Walter L. Field: Activist, Founder of Jewish News." December 26, 1999.

Detroit Historical Society. "Encyclopedia of Detroit: Corktown Historic District." https://detroithistorical.org/learn/encyclopedia-of-detroit/corktown-historic-district.

———. "Encyclopedia of Detroit: Purple Gang." https://detroithistorical.org/learn/encyclopedia-of-detroit/purple-gang.

———. "Encyclopedia of Detroit: R.H. Fyfe & Co." https://detroithistorical.org/learn/encyclopedia-of-detroit/rh-fyfe-co.

———. "Encyclopedia of Detroit: Uprising of 1967." https://detroithistorical.org/learn/encyclopedia-of-detroit/uprising-1967.

———. "Encyclopedia of Detroit: Vernor's Ginger Ale." https://detroithistorical.org/learn/encyclopedia-of-detroit/vernors-ginger-ale.

Detroit Police Department. "2015 Annual Report." http://www.detroitmi.gov/Portals/0/docs/Police/DPD2015AnnualRptWeb.pdf?ver=2016-05-02-120534-437.

EstateSales.net. "Liquidating Contents of 100 Year Old DelRay Bar." https://www.estatesales.net/MI/Detroit/48209/1627956.

Farrell, Perry. "Better Made Potato Chips Changes Iconic Sign at Detroit Headquarters." Detroit Free Press, April 12, 2017. https://www.freep.com/story/news/local/michigan/detroit/2017/04/12/better-made-sign-detroit/100366692.

Federal Bureau of Prisons. "Find an Inmate." https://www.bop.gov/inmateloc.

Ferretti, Christine. "Henry the Hatter Reopens Friday in Eastern Market." Detroit News, December 7, 2017. http://www.detroitnews.com/story/business/2017/12/07/henry-hatter-detroit-opens/108412178.

4731 Art Gallery and Studios. "About." http://4731.com/about.

Gallagher, John. "Microsoft's Move Boosts Detroit's Credibility as Tech Hub." Detroit Free Press, February 3, 2017. https://www.freep.com/story/money/business/columnists/2017/02/03/detroit-microsoft-gilbert-duggan-technology-innovation/97439840.

Gavrilovich, Peter, and Bill McGraw. *The Detroit Almanac: 300 Years of Life in the Motor City*. Detroit, MI: Detroit Free Press, 2000.

George, Hub M., and Jerome Hansen. "Williams, Legislators Assail Rathnaw's Liquor Proposals." *Detroit Free Press*, January 21, 1954.

Gerstein, Michael, and Shawn D. Lewis. "24 Detroit Schools Risk Summer Shutdown." *Detroit News*, January 23, 2017.

Gibson, Campbell, and Kay Jung. "Historical Census Statistics on the Foreign-Born Population of the United States: 1850 to 2000." United States Census Bureau, February 2006.

Golden, Harry, Jr. "Why a Father Sheds His Blood and Tears." *Detroit Free Press*, April 13, 1957.

Hargraves, Randy. Interview with the author, November 29, 2017.

Historic Detroit. "Detroit Savings Bank Building." http://www.historicdetroit.org/building/detroit-savings-bank-building.

———. "Loyal Order of Moose Lodge." http://www.historicdetroit.org/building/loyal-order-of-moose-lodge.

Holland, Tim. "Once-Famous Fyfe Co. Folds." *Detroit Free Press*, October 2, 1971.

Iggers, Jeremy. "Fresh Off the Farm." *Detroit Free Press*, August 12, 1981.

Irvine, Brooksey James, Jr. Interview with the author, December 20, 2017.

Kenyon, Norman. "Try Horse Meat Steak or Fried Muskrat." *Detroit Free Press*, February 12, 1945.

King, John. Interview with the author, July 23, 2017.

King, R.J. "Historic Farwell Building in Detroit's Capitol Park Set to Open in Fall 2017." *DBusiness*, August 26, 2016. http://www.dbusiness.com/daily-news/Annual-2016/Historic-Farwell-Building-in-Detroits-Capitol-Park-Set-to-Open-in-Fall-2017.

Kinsler, Carolyn. Interview with the author, summer of 2017.

Klein, Dave. Interview with the author, September 7, 2017.

Kohn, Anna. E-mail to the author, September 11, 2017.

Kovel, Terry. "Artists' Unique Glass Pieces Fuse Place in History." *Las Vegas Review-Journal*, March 14, 2013. https://www.reviewjournal.com/life/home-and-garden/artists-unique-glass-pieces-fuse-place-in-history.

Kurlyandchik, Mark. "Ford Field Top Chefs Leave Stadium to Launch Premium Chocolate Company." *Detroit Free Press*, December 14, 2017. https://www.freep.com/story/entertainment/dining/mark-kurlyandchik/2017/12/14/ford-field-chefs-leave-launch-chocolate-company-bonbon-guilt-chocolates-joe-nader-scott-breazeale/951308001.

Laitner, Bill, and Robert Allen. "Detroit TV Commercial Star 'Mr. Belvedere' Dies at Age 95." *Detroit Free Press*, March 27, 2017. https://www.freep.com/story/news/local/michigan/oakland/2017/03/27/mr-belvedere-obituary-maurice-bud-lezell-dies/99687482.

Lindmeier, Alex. Interview with the author, June 10, 2017.

Livengood, Chad. "After 92 Years in Detroit, Simmons and Clark Jewelers Refreshes Store, Bridal Business." *Crain's Detroit Business*, April 20, 2017. http://www.crainsdetroit.com/article/20170420/BLOG026/170429994/after-92-years-in-detroit-simmons-and-clark-jewelers-refreshes-store.

Loomis, Bill. "When Frogs Were King." *Hour Detroit*, April 28, 2014. http://www.hourdetroit.com/Hour-Detroit/May-2014/When-Frogs-Were-King.

Lyons, Mickey. "Sugar House's Dave Kwiatkowski Buys Historic Delray Bar." *Detroit Metro Times*, August 5, 2017. https://www.metrotimes.com/table-and-bar/archives/2017/08/05/sugar-houses-dave-kwiatkowski-buys-historic-delray-bar.

McGraw, Bill. "The Neighborhood: Pain and Hope." *Detroit Free Press*, September 8, 1985.

Michigan Department of Licensing and Regulatory Affairs Corporations, Securities and Commercial Licensing Buerau. "Trademarks and Service Marks; Report Date: 10/6/2017." https://www.michigan.gov/documents/lara/markcomm-z_526723_7.pdf.

Michigan State Senate. "The First Capitol." http://www.senate.michigan.gov/history/capitolhistory.html.

Moore, Edward. Interview with the author, July 18, 2017.

Moss, Caleb. Interview with the author, November 28, 2017.

Nancy Whiskey Pub. http://www.nancywhiskeydetroit.com.

National Park Service. "Corktown Historic District." https://www.nps.gov/nr/travel/detroit/d19.htm.

National Public Radio. "Battling Blight: Detroit Maps Entire City to Find Bad Buildings." February 18, 2014. https://www.npr.org/2014/02/14/277058384/battling-blight-detroit-maps-entire-city-to-find-bad-buildings.

Nowotny, Fred. Interview with author, November 20, 2017.

Olejnik, Richard. Interview with the author, October 27, 2017.

Pinho, Kirk. "Park Avenue Building Downtown Hits Market After Owner's Death." *Crain's Detroit Business*, September 20, 2017. http://www.crainsdetroit.com/article/20170920/news/639816/park-avenue-building-downtown-hits-market-after-owners-death.

Pomerantz, Steven. "Fort Gratiot." *Belt Magazine*, October 21, 2013. http://beltmag.com/fort-hardware.

Pooler, James S. "Businessman-Poet." *Detroit Free Press*, July 7, 1963.

Preservation Detroit. "Repairs Ordered for Park Avenue Building #KeepParkAve." September 22, 2014. http://preservationdetroit.org/keep-the-park-avenue-building-keepparkave.

Ramsey, Mike. "Borders Makes Habit of Being First to Go in Downtown." Associated Press, June 10, 2004.

Recovery Park. "About Us." http://www.recoverypark.org/about-us.

Rector, Sylvia. "Detroit's Better Made Potato Chips Turns 85." *Detroit Free Press*, March 12, 2015. https://www.freep.com/story/life/food/2015/03/12/better-made-potato-chips-turns/70244328.

Rouch, Lawrence L. *The Vernor's Story: From Gnomes to Now*. Ann Arbor: University of Michigan Press, 2003.

Runyan, Robin. "10 Detroit Developments Set to Debut in 2018." *Curbed Detroit*, December 15, 2017. https://detroit.curbed.com/maps/10-detroit-developments-debut-2018.

Rusted Crow Detroit—Gastrolounge. "Our Drinks." http://rustedcrowdetroit.com/#cocktails.

Rzedzian, Pawel. Interview with the author, summer of 2017.

Santich, Kate. "Muralist Creates Pulse Tribute to Help Community Heal." *Orlando Sentinel*, October 19, 2016. http://www.orlandosentinel.com/news/pulse-orlando-nightclub-shooting/os-pulse-nightclub-mural-street-art-20161019-story.html.

Schlicker, Debbie. Interview with the author, December 5, 2017.

Schlicker, Gary. Interview with the author, December 5, 2017.

Shea, Bill. "Built by Immigrants: Foreign-Born Workers Integral Part of Detroit's History, Economy." *Crain's Detroit Business*, June 1, 2014. http://www.crainsdetroit.com/article/20140601/NEWS/306019993/built-by-immigrants-foreign-born-workers-integral-part-of-detroits.

Simmons, Michael. Online conversations with the author, September 22, 2017, and December 24, 2017.

Sindbads Restaurant and Marina. "Dining Room Menu." http://sindbads.com/wp-content/uploads/FF-MENU-FEB.-2017-1.pdf.

The Skip. "Drink Menu." http://www.theskipdetroit.com/drink-menu.

Stage, William. *Ghost Signs: Brick Wall Signs in America*. Cincinnati, OH: ST Publications Inc., 1989.

Stroh Brewery Company. "History." http://strohbeer.com.

Stroh, Frances. *Beer Money: A Memoir of Privilege and Loss*. New York: HarperCollins Publishers, 2016.

Stromberg, Warren H. "And Whatever Happened to—the Starving Nowotnys?" *Detroit Free Press*, December 22, 1957.

Thibodeau, Ian. "Housing Plans on for Spring 2018 at Tiger Stadium Site." *Detroit News*, August 18, 2016.

Trbovich, Marco. "Celebrating the Good Life of the Gypsies at Kovacs', Last of the Great Hungarian Bars in Old Delray." *Detroit Free Press*, May 21, 1972.

Trop, Jaclyn. "Borders to Close Detroit Store." *Detroit News*, January 29, 2009.

Tschirhart, Don. "28 to Be Honored for 'Heroism' Beyond the Call of Duty." *Detroit News*, May 12, 1991.

United States Census. "Nativity of the Population for the 50 Largest Urban Places: 1870 to 2000." https://www.census.gov/population/www/documentation/ twpso0081/tables/tab23.csv.

———. "QuickFacts; Detroit City, Michigan." https://www.census.gov/quickfacts/ fact/table/detroitcitymichigan/PST045216.

———. "2012–2016 American Community Survey 5-Year Estimates." https://factfinder.census.gov/faces/nav/jsf/pages/community_facts. xhtml?src=bkmk.

United States District Court, Eastern District of Michigan (Detroit). "Criminal Docket for Case#: 2:99-cr-80664-PJD-2, *USA v. Carpenay, et al.*" Filed July 15, 1999.

What's Cooking America. "Milk Chocolate History." https://whatscookingamerica. net/History/MilkChocolate.htm.

Williams, Candice. "Construction Pitchman 'Mr. Belvedere' Dead at 95." *Detroit News*, March 27, 2017. http://www.detroitnews.com/story/ obituaries/2017/03/27/belvedere-obit/99713836.

Windsor-Detroit Bridge Authority. "Gordie Howe International Bridge Project— Project Component Overview Images." https://www.wdbridge.com/en/gordie- howe-international-bridge-project-project-component-overview-images.

Winge, Ed. "Big-Hearted Detroit." *Detroit Free Press*, April 14, 1957.

Witsil, Frank. "Is Bowling in Its Final Frames or Will It Roll On?" *Detroit Free Press*, May 10, 2015.

———. "Minority-Owned Construction Business Rebuilding Detroit." *Detroit Free Press*, January 28, 2017. https://www.freep.com/story/money/ business/michigan/2017/01/28/larry-brinker-construction-management- detroit/97086848.

Yellow Tigers Karate. "Historical Overview." http://www.yellowtigerskarate.com/ about-ytk.

Zaniewski, Ann. "Polish Pride to Be on Display at St. Albertus Mass Mob, Pierogi Festival." *Detroit Free Press*, August 10, 2017. https://www.freep.com/story/ news/local/michigan/detroit/2017/08/10/mass-mob-pierogi-festival- detroit/546254001.

Zielke, Jordan. Interview with the author, July 17, 2017.

INDEX

ABOUT THE AUTHOR

ROBERT ALLEN was born in Arlington, Texas, in 1984. A graduate of Oklahoma State University in 2006, he reported for newspapers across Colorado—the *Montrose Daily Press*, *Summit Daily News* in Breckenridge and *Fort Collins Coloradoan*—before joining the *Detroit Free Press*. He writes about crime, malevolent sand dunes, history, disasters and craft beer. His work, spanning datelines in three countries, has included coverage of catastrophic wildfires, floods, the Flint Water Crisis, the Dakota Access Pipeline protests and the consumption of more than one thousand different craft beers.

His accomplishments include a frigid, three-week January whitewater rafting trip down the Grand Canyon, numerous backpacking adventures in U.S. forests and a collection of journalism awards, such as a Hearst in-depth writing award for immigration coverage and a first-place award from the Colorado Associated Press for marijuana reporting.

His work has appeared in *USA Today*, the *Chicago Tribune*, the *Denver Post*, the *Arizona Republic*, the *Indianapolis Star*, the *Des Moines Register*, the *Cincinnati Enquirer* and others. He has appeared on HLN and on the Oxygen channel program *Snapped*.

His previous work includes waiting tables, weight-guessing and house painting. He lives in Ferndale with his wife, Rachel, and they aspire to adopt a dog. His interests include smoked chicken wings, American football and the wilderness.

Visit us at
www.historypress.net